MODERN ART AT HARVARD

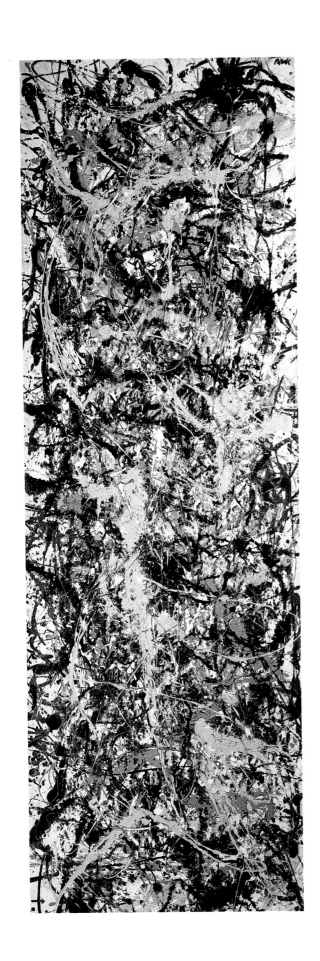

Modern Art at Harvard

The Formation of the

Nineteenth– and Twentieth–Century Collections

of the Harvard University Art Museums

Caroline A. Jones

With an essay by

John Coolidge

and a preface by

John M. Rosenfield

Abbeville Press · Publishers · New York

Harvard University Art Museums · Cambridge

Front cover:
PABLO PICASSO, *Woman in Blue* (fig. 78).

Back cover:
FRANK STELLA, *Hiraqla II* (fig. 73).

Art director: James Wageman
Designer: Carl Lehmann-Haupt
Editors: Alan Axelrod and Amelia Jones
Production manager: Dana Cole

Published in the United States of America
in 1985 by Abbeville Press, Inc.

LIBRARY OF CONGRESS CATALOGING IN PUBLICATION DATA
Jones, Caroline A.
 Modern art at Harvard.

 Includes index.
 1. Art, Modern—19th century. 2. Art, Modern—
20th century. 3. Art—Massachusetts—Cambridge.
4. Harvard University—Museums. 5. Art museums—
Massachusetts—Cambridge. I. Title.
N6447.J65 1985 709′.03′407401444 85-11108
ISBN 0-89659-592-7 ISBN 0-89659-595-1 (pbk.)

Frontispiece:
JACKSON POLLOCK
*(1912–1956) American
No. 2, 1950. Oil, lacquer, duco and
pebbles on canvas. 287 x 91.4 cm.
(113 x 36 in.). 1965.554. Gift, Mr.
and Mrs. Reginald R. Isaacs and
Family and Purchase, Contempor-
ary Art Fund.*

*In the late 1940s and 1950s, Pollock
became America's most famous ab-
stract artist, perceived as part char-
latan, part genius. No. 2, 1950
exemplifies his celebrated "drip
technique," in which he layered
skeins of dripped and spattered
paint onto unprimed canvas rolled
out on the studio floor. Although he
would often cut the finished can-
vases into smaller pieces to create
individual paintings, in No. 2 he
has maintained the integrity of the
fabric, stapling its edges directly to
the mount and leaving its selvages
visible and intact. This work, which
contains grainy pebbles in the paint,
may have been influenced by Pol-
lock's admiration for the American
Indian sand painters, who worked
on the ground, trancelike, from four
sides of their ephemeral images.
Pollock explained his own ap-
proach, stating that "On the floor I
am more at ease. I feel nearer, more
a part of the painting, since this way
I can walk around it, work from the
four sides, and literally be in the
painting."*

Contents

ing of modernism arrived with European artists and intellectuals who had been displaced by the rise of Fascism. Among those who came to Harvard were the great architect and theoretician Walter Gropius, who became dean of the Harvard School of Design in 1937, and Jakob Rosenberg, who became curator of prints at the Fogg Museum in 1939 after seventeen years in the print room at the Berlin Museum.

Beginning shortly before the outbreak of World War II and continuing to this day, prominent modernists have been appointed to the Charles Eliot Norton Professorship of Poetry, which is broadly conceived to cover all poetic expression in language, music, fine arts, and architecture. T. S. Eliot (1932–33), Siegfried Giedion (1938–39)—whose influential lectures were published in five successive editions as *Space, Time and Architecture: The Growth of a New Tradition*—Igor Stravinski (1939–40), Sir Herbert Read (1953–54), Ben Shahn (1956–57), Pier Luigi Nervi (1961–62), Charles Eames (1970–71), and, most recently, Frank Stella (1983–84) are among those who have been appointed Norton professors. In 1961, Wassily Leontief, head of the Harvard Society of Fellows, commissioned a set of abstract paintings by Mark Rothko for the Fellows' dining room in the penthouse of the new Holyoke Center designed by Josep Lluis Sert. These great paintings have since been placed under the care of the art museums. The university has also commissioned innovative buildings by Gropius and Le Corbusier.

Courses on modern art entered the curriculum of the fine arts department immediately after World War II, and gifted graduate students devoted themselves to the history and criticism of contemporary art. Joseph Pulitzer, Jr., has endowed a chair in "Contemporary Art," defined as the art of our times and meant to include the art of the future as well.

It is impossible to say whether *modernism* will ever again be synonymous with *contemporary*. For modernism has reached a crucial juncture, as some critics claim that the movement has come to an end and advise artists and builders to return to traditional sources of form. Many leading architects are abandoning the starkly geometric industrialized forms of the International Style and have begun to employ applied ornament, strong colors, and historical references in their buildings. In the vanguard of this tendency is the British architect James Stirling, who was commissioned by the university in 1979 to design the new Arthur M. Sackler Museum, a building he has imbued with a

richness of detail and a sense of expressive form that deviate markedly from the canons of the International Style.

It is appropriate that this book, which draws a portrait of Harvard's interaction with the art of its time, should, in part, mark the public opening of this exciting new facility, whose special exhibition gallery will house the principal portion of this collection of modern art. Other parts of the exhibition will be installed in the Fogg and the Busch-Reisinger museums, celebrating the creation of the new entity, the Harvard University Art Museums.

On behalf of the staff of the art museums I wish to acknowledge a great debt of gratitude to Caroline A. Jones for organizing the exhibition and writing this book and to John Coolidge for his evocative reminiscences. Joseph and Emily Pulitzer offered many useful suggestions, and without the practical assistance of Lisa Flanagan, Leonie Gordon, and Peter Walsh this publication would not have appeared. The museums would also like to thank the National Endowment for the Arts for its helpful support of this inaugural exhibition.

John M. Rosenfield

Abby Aldrich Rockefeller Professor of Oriental Art

Acting Director, Harvard University Art Museums

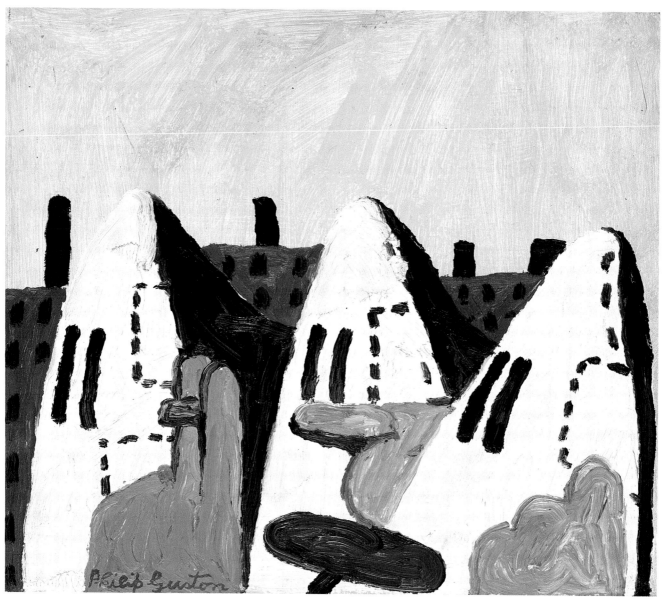

2. PHILIP GUSTON

(1913–1980) American
The Three *(1970). Oil on panel. 30.5*
x 35.6 cm. (12 x 14 in.). 1976.9. Pur-
chase, Louise E. Bettens Fund.

In 1970 Philip Guston, still identi-
fied as an eminent Abstract Expres-
sionist, exhibited a group of paint-
ings that appeared to repudiate the
goals of this famous group of New
York School painters. While it is true
that his reputation is grounded in
the flickering abstract brushstrokes

of his work in the 1940s and 1950s,
Guston had earlier been a muralist
for the Depression-era W.P.A., where
his interest in social issues and cari-
cature had first developed. His as-
tonishing "new figuration" thus
represented a return to earlier con-
cerns, exemplified in The Three.
Hooded figures recalling Ku Klux
Klansmen huddle together, one
smoking a stubby cigar. Violence is
implied in these late paintings by the
general air of conspiracy, made ex-

plicit in some works by piles of accu-
mulated shoes (whose ancestors were
collected from concentration camp
victims) or severed limbs. In its men-
acing aspect, The Three *attests to*
what some artists of "the heroic
generation" (such as Jackson Pol-
lock, with whom Guston had grown
up in Los Angeles) came to see as the
inability of abstraction to represent
their growing concern with figura-
tion and, in Guston's case, with so-
cial issues during the 1960s.

Acknowledgments

MY DEEPEST DEBT of gratitude goes to John Rosenfield, whose vision animated this project from the very beginning. It was Professor Rosenfield's idea to feature the modern collections at the inaugural moment—a decision made all the more remarkable by the fact that his first loyalty is to Oriental art, newly installed in the Sackler Museum.

Researching this book and selecting works for the exhibition were formidable tasks, given the wealth of Harvard's collection. The job was made easier by Mrs. Phoebe Peebles, the museums' archivist, and her assistant Abby Smith; Richard Simpson and the staff of the Fine Arts Library were invariably helpful in locating materials. Leonie Gordon in the director's office proved an able editor and, with her assistant José Mateo, generously spared time to help with research for the book's captions. Curators Davis Pratt, Konrad Oberhuber, and Henri Zerner took time to help with the captions, and their respective assistants Mignon Nixon, Miriam Stewart, and Jonathan Bober assisted frequently with both caption and catalogue information.

The text of this book benefited from the thoughtful comments and suggestions of many. Peter Nisbet, Assistant Curator of the Busch-Reisinger, read several sections and helped amplify the discussion of the Busch's many contributions to Harvard's understanding of the modern movement; his assistant Emilie Dana located much useful archival information on the history of the Busch and its collections. Discussions with Professor James Ackerman and Curator Emeritus Agnes Mongan shed light on a few mysteries in the Fogg's past; Elisabeth Sussman, Chief Curator at the Institute of Contemporary Art in Boston, was enormously helpful in my efforts to gauge the impact of that institution on Boston's contemporary scene. Anna Chave, Assistant Professor of Fine Arts, and John O'Brian, advanced graduate student in the department, read early drafts of the manuscript and made many helpful suggestions. Mrs. Marjorie Cohn, Associate Conservator in the Fogg's Center for Conservation Studies, read the first chapter and caught several errors that happily never saw print; John Coolidge likewise spotted many of what he labelled "howlers." His candor and remarkable memory in our interviews served as the basis for much of my research, and I am forever in his debt for the generosity with which he read and wrote drafts for the present publication.

There are a few individuals without whose constant diligence this book would not have been possible. Amelia Jones, Abbeville picture editor and general project editor, monitored the book's progress from its inception and helped me navigate the stormy sea of editorial imperatives, reproduction permissions, and endless Federal Express deadlines. Moreover, she researched and drafted half of the caption entries and helped edit the remainder. Her determination to see the book to press—and her enthusiasm about the art objects themselves—often carried the author to the next stage of the project, despite exhaustion. Peter Walsh, the museums' Manager of Publications and Public Relations, read countless drafts of the manuscript, argued constructively about several of my interpretations, and proved a sanguine source of support and solid editorial advice. Alan Axelrod, editor at Abbeville Press, was patient, thorough, and encouraging.

For their handling of the administrative details of the book's production, the entire staff of the museums' Photo Services Department should be praised. Elizabeth Gombosi, Martha Heintz, Mike Nedzweski, and Rick Stafford— under the helpful supervision of Lisa Flanagan—met the various deadlines imposed on them with professional speed. Ada Bortoluzzi and Tim Novak in my own office performed innumerable tasks for both the book and exhibition. The museums' Registrar, Jane Montgomery, her assistant Maureen Donovan, and museum conservators Marjorie Cohn, Teri Hensick, Henry Lie, and Kate Olivier made certain that the works would be in good shape for installation. Without the operations department staff—Kate Eilertsen, Joao de Melo, Philip Parsons, and Michael Williams—the works could not have been installed at all.

The museums' most enduring gratitude goes to its donors, without whose generosity the exhibition—and indeed, the collections themselves—would not be possible. Mr. and Mrs. Joseph Pulitzer, Jr., were most cooperative and supportive of the project, and Dr. John Spiegel was also helpful. Past and present donors too numerous to mention are perhaps best served by the exhibition itself, and by this book, which seeks to tell their story.

Finally, I owe my warmest thanks to Peter Galison, who contributed many hours of late-night conversation, and much treasured friendship, throughout this project.

MODERN ART AT HARVARD

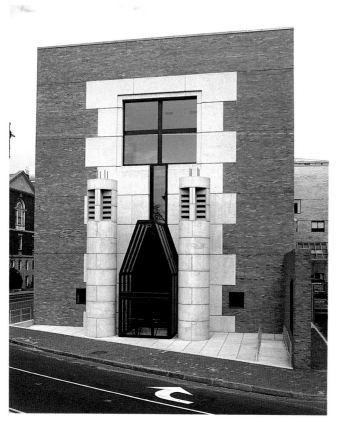 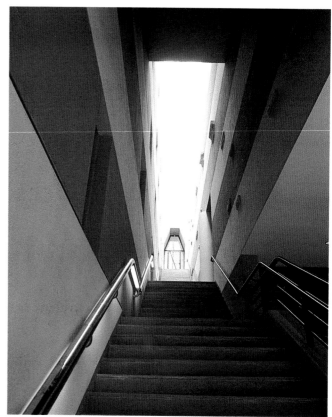

3, 4. *Exterior and interior of the new
Arthur M. Sackler Museum, 1985.*

Introduction

WITH the opening of the Arthur M. Sackler Museum, the Harvard University Art Museums can present their collections comprehensively for the first time in over four decades. "Modern Art at Harvard," which will occupy the Busch-Reisinger and Fogg museums as well as the Sackler, celebrates this event and opens the museums' inaugural year. The exhibition and this book introduce the museums' extensive and largely unpublished holdings of late nineteenth- and twentieth-century art. The essay that follows describes the formation of these collections and the ideas about modernism that shaped them.

Because the Harvard museums acquired works for the purpose of teaching, the collections offer particularly salient examples of given styles, periods, or movements in modern art. The collections lack the comprehensiveness found in a museum dedicated solely to the art of our time, yet the gaps themselves tell an important story about the way in which a major research institution viewed modern art and how it taught students to approach it. In some ways typical of the larger context in which modern art was received or rejected, the men and women who formed the present collections also participated in traditions peculiar to Harvard, anachronistic traditions sometimes inimical to modern art.

As John Rosenfield has suggested in his preface, some of these traditions drew their inspiration from ideas and philosophies attributed to the ancient world or to the medieval age, whose spiritual integrity was highly valued by New England intellectuals. Whether the classical or the medieval was venerated, the views of these men and women reflected certain *moral* ideas, and the art they prized was seen as necessarily "uplifting." Certainly, many modern artists inherited this yearning for the union of ideal forms and moral purposes. The artists of the German Bauhaus, the Russian constructivists, or the theorists affiliated with the Dutch de Stijl come to mind as examples. But, as incarnated at Harvard, such traditions and moral yearnings were largely conservative influences.

Counterposed to this conservatism, which lingered longer in Boston than in

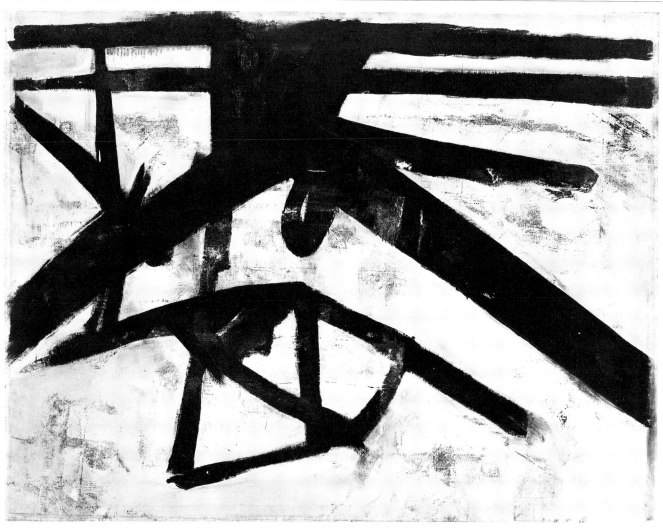

5. FRANZ KLINE
(1910–1962) American
High Street *(1951). Oil on canvas.*
147.3 x 195.6 cm. (58 x 77 in.).
1971.121. Gift, Lois Orswell. See
extended caption, page 112.

New York, was a powerful liberalizing force: the progressive laboratory ideal, in which a commitment to direct experience fostered an openness to experimentation. The spirit of experimentation extended to the Fogg Museum, which, from its inception, was described as an "art laboratory" where artworks could be analyzed and compared, rather than as a treasure house built to enshrine a cultural legacy. For modern as well as more traditional art, the influence of the new museum would be felt not through large public exhibitions or innovative acquisitions but through ideas that could be tested and explored in a laboratory of fine arts.

The dynamic between the forces of innovation and conservation fueled the collecting of a particular kind of modern art, which, however radical, never jeopardized the idea of standards and the role of connoisseurship in judging quality. The Fogg Museum was founded in 1891, the Busch-Reisinger (known originally as the Germanic Museum) around 1897. Until the 1970s, both museums were governed by an unbroken line of spiritual successors, de-

scending from Charles Eliot Norton and Charles Herbert Moore to their students, Edward Waldo Forbes and Paul Joseph Sachs, to *their* students, Charles Kuhn, Agnes Mongan, and John Coolidge. The evolution of "modern art" at Harvard, defined at first as "the art of our time" rather than as an intellectually or aesthetically identifiable movement, is thus partly a function of this inheritance and partly a function of the changing status of modern art in the world at large. The following essay traces this shifting status—and the changing definitions of "modern art" that it implies—as well as the developing role of the modern collection in teaching at Harvard. John Coolidge, William Dorr Boardman Professor of Fine Arts (Emeritus), has also offered his informal reminiscences of the central and formative decades during which he was director.

In selecting works for the exhibition, we began with those artists first considered "modern" by the museums' earliest directors: namely, that generation of French painters who came to maturity under the banner of Impressionism. While some current thinking projects the origins of modernism back to the eighteenth century or earlier, considerations of space prevent the inclusion of the Barbizon painters or the Pre-Raphaelites, despite their appeal for the museums' first great collectors.[1] The book and exhibition thus begin with European painting from 1860, take up American painting when it begins to reflect formal innovations from abroad, and extend to the present, where works on paper show the growing strength in the museums' contemporary holdings.[2]

Note on the captions: Dates given in parentheses are not inscribed on the works themselves but have been documented in other ways; dates not enclosed in parentheses are those inscribed by the artist on the work of art or its support. For two-dimensional works, height precedes width; for three-dimensional works, height precedes width precedes depth. Sources of quotations and other factual material in the captions follow the endnotes.

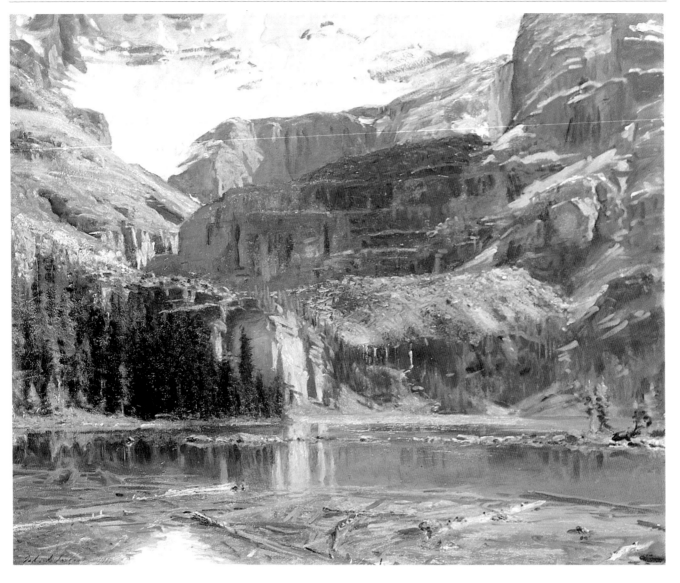

6. JOHN SINGER SARGENT
(1856–1925) American
Lake O'Hara, *1916. Oil on canvas.*
94.6 x 111.8 cm. (37¼ x 44 in.).
1916.496. Purchase, Louise E.
Bettens Fund.

Lake O'Hara *was the first painting*
by a living modern artist purchased
by the Fogg; indeed, the museum ac-
quired it immediately after its com-
pletion. In contrast to the earlier
tradition of the American romantic
landscapists of the Hudson River

School, Lake O'Hara *exhibits a pro-*
nounced impressionistic brush-
stroke. In addition, in place of the
idyllic, Sargent has included such
realistic—and potentially disturb-
ing—elements as the rotting logs in
the foreground. A freshly observed
outdoor work, this depiction of the
artist's holiday spot in the Canadian
Rockies bears little resemblance to
Sargent's later paintings, for the
most part virtuoso portraits of the
European and American elite.

1 "The Education and Enlightenment of the People," 1891–1915:

Beginnings of the Fogg Collection

NINETEENTH-CENTURY Harvard was a sheltered, provincial academy that provided a classical education but few practical or professional skills. When the American architect H. H. Richardson graduated from Harvard in 1859, two-thirds of his courses were in classics and mathematics, with a single class in science. As Henry James wrote in his biography of Charles W. Eliot, president of the college from 1869 to 1909:

The studies which a Harvard student pursued in 1849 [when Eliot was an undergraduate] were definitely laid down and limited in scope. The teaching staff of thirteen . . . drilled the boys in Latin, Greek, and mathematics, taught them a little history, led them to what we should call a merely superficial glance at the moral and natural sciences; and when they became seniors, offered them an opportunity to catch a brief glimpse of European literature in a very agreeable way by attending Professor Longfellow's weekly lectures.

It was not until after the Civil War that the quickening industrial sciences began to liberalize higher education in America. The Massachusetts Institute of Technology opened in 1865, having been conceived by its founder, William Barton Rogers, as "a Society of Arts, a Museum of Arts and a School of Industrial Science." Its first professor of architecture traveled to Europe to acquire photographs, plaster casts, and prints for teaching.[1]

When the Museum of Fine Arts in Boston was chartered in 1870, an instructor in fine arts and design was appointed along with the first director, well before any curatorial staff. The Metropolitan Museum of Art opened in New York that same year, and municipalities across the country began to demand museums of science and art.[2] Similar impulses operated in Europe in great industrial expositions such as the 1855 *Exposition Universelle* in Paris, London's Crystal Palace, built in 1851, and the Paris World's Fair of 1891. These highly publicized "educational" enterprises brought together arts, crafts, science, and industry in bold new ways. In America, the trend reached its apogee in the centennial expositions of 1876, with the installation of the Smithsonian's Palace of Arts and Industry in Washington, D.C.

Influenced by this new interest in the role of applied arts and industrial

sciences in education, Charles W. Eliot wrote to a friend that "the Puritans thought they must have trained ministers for the Church and they supported Harvard College—when the American people are convinced that they require more competent chemists, engineers, artists, architects than they now have, they will somehow establish the institutions to train them." Eliot, who was teaching chemistry at MIT at the time, acted on his conviction that modern education should start with direct, hands-on experience of a subject. In his course for chemistry teachers, he insisted that they "work themselves with their own eyes and fingers" and make their own observations "without imitating or copying" from textbooks—a vast change from the rote learning and recitation required during his own days as a Harvard undergraduate.[3] Such teaching required laboratories—and scientific collections to go with them.

When Eliot became Harvard's president in 1869, his interest in laboratory science and applied arts motivated a broad range of educational reforms, forcing the university into the modern age. His efforts to promote the arts resulted in the 1874 appointment of Charles Eliot Norton to the position of "Lecturer on the History of the Fine Arts as Connected with Literature." When Norton was named professor a year later, Harvard became the first university in America with an art history chair.

Norton was a close friend of John Ruskin, the most influential art critic in nineteenth-century England, and was deeply inspired by his work.[4] Ruskin's view of art as an expression of Christian morality and his resistance to the antiartistic tendencies of modern life were mirrored in Norton, who also shared Ruskin's high esteem for the English Pre-Raphaelites. Like Ruskin, Norton also felt that the direct practice of art was crucial to its appreciation, and one of his first initiatives as lecturer was to arrange for the appointment of Charles Herbert Moore as instructor in drawing and the principles of design. An expert on Gothic architecture, Moore had painted with Ruskin in Venice and shared Norton's veneration for the English theorist's views on art.

Significantly, Moore had begun his Harvard career at the Lawrence Scientific School, founded in 1847 by two Harvard scientists in order to address the lack of practical education at the college and to establish "an advanced school in Science and Literature."[5] Among the first graduates were men like John Runkle, who would become president of MIT, the psychologist William James, the curators of natural history museums in New York and Chicago, several

architects, and the first director of the Boston Museum of Fine Arts, Charles Greely Loring. The concept of the school was directly opposed to the traditional classical curriculum, and its courses were not available to undergraduates. Moore's pioneering course in drawing had thus been first offered as a specialized skill needed for scientific description, and not as part of a liberal education. It was only under President Eliot that the classical and applied curricula were united.

The rise of the natural sciences thus had an important influence on the development of fine arts at Harvard. It encouraged a more practical study of the applied arts and contributed the concept of the learning laboratory, so crucial to early teaching at the Fogg. The idea for a teaching collection at Harvard had its origin in the vast collections of plant and animal specimens assembled for the university by the pioneer American naturalist Louis Agassiz, who designed them to illustrate his theories of creation and evolution. Agassiz dreamed of a permanent natural history display to serve as a teaching and research arm of the university as well as a rich public resource. His vision became reality when Harvard and the State of Massachusetts, with the help of a bequest from the Boston lawyer Francis Calley Gray, founded the Museum of Comparative Zoology in 1859.[6] Gray, no doubt affected by the educational goal of Agassiz's proposed "comparative museum," also left to Harvard his extraordinary collection of reproductive and fine art engravings, unmatched in America at the time and notable even today for its quality and range. This collection was intended to serve the fine arts in the same way that Agassiz's zoological museum would serve the natural sciences.

Louis Agassiz was a magnetic force in the intellectual and cultural life of America, as was his wife Elizabeth (who helped found Radcliffe College in 1879) and his son Alexander (who succeeded him at the Museum of Comparative Zoology). In his capacity as a member of Boston society and as first cousin to President Eliot, Norton would have known the Agassiz family well. Likewise, Charles Moore would have been familiar with Agassiz's work and with the zoology collections.[7] Norton's lectures on classical and medieval civilization, together with Moore's scientifically inflected drawing courses, established from the beginning "that instruction in the history of art should be accompanied by instruction in theory and principles, that the training of eye and hand is no less important than the training of memory."[8]

The new program was highly successful. Norton taught in the largest hall of

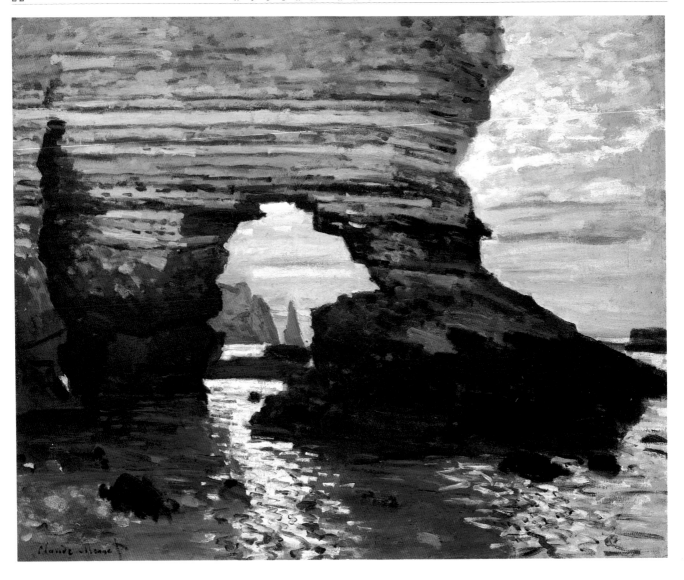

7. CLAUDE MONET
(1840–1926) French
Cliff at Etretat *(c. 1868). Oil on canvas. 81.3 x 100.3 cm. (32 x 39½ in.). 1957.163. Gift, Mr. and Mrs. Joseph Pulitzer, Jr.*

A relatively early Monet, Cliff at Etretat *maintains a firm structural integrity without compromising the strongly articulated brushwork that is the artist's trademark. Etretat, on the Normandy coast, was a favored setting for many artists, including Gustave Courbet and Whistler. Monet traveled there in 1868 with Courbet and the novelist Alexandre Dumas (père), at which time he probably created this canvas. For many years the painting was owned by the celebrated Parisian dealer and advocate of the French Impressionists, Fernand Durand-Ruel; it was acquired in 1955 by the Pulitzers, who donated it to the Fogg two years later.*

8. PIERRE AUGUSTE RENOIR
(1841–1919) French
Portrait of M. Choquet *(1875). Oil on canvas. 45.7 x 36.8 cm. (18 x 14½ in.). 1943.274. Bequest, Grenville L. Winthrop.*

Choquet was a French customs official who devoted his income to buying art. He was also active in introducing artists to one another. Renoir described this sensitive painting as "a portrait of a madman by a madman" ("un portrait d'un fou par un fou"). The artist, who first met Choquet in 1875, showed this work at the Second Impressionist Exhibition in Paris, 1876.

the university, and by the end of the 1890s his classes had the highest attendance. Eloquent and inspiring introductions to human culture, his lectures often contrasted the shallowness of American civilization with the greatness of the ancient world and Europe.[9] Surprisingly, Norton used no slides or photographic prints and only rarely suggested that students study objects—mostly casts at the time—in the Museum of Fine Arts. His role was to ignite the imagination, and from his tutelage came such scholars as Bernard Berenson and Ernest Fenollosa, as well as the collector Grenville Winthrop and Fogg director Edward Forbes. It is probable that Norton also inspired William Prichard, who gave the university its first funds earmarked solely for the acquisition of art.

Prichard was also the lawyer who drew up the will of Mrs. William Hayes Fogg, widow of a New York businessman with no prior connection to the university. In 1891 Harvard received notice that Mrs. Fogg had left in her will the sum of $220,000 for the construction and endowment of "a fire-proof structure of ornamental and appropriate architecture to be used for the collection and exhibition of works of art of every description and for the education and enlightenment of the people in respect to art."[10] The university appointed a two-man "Building Committee" (Martin Brimmer, class of 1849, then the president of the Museum of Fine Arts, and Edward Hooper, class of 1859, one of its trustees). They proceeded to commission the distinguished

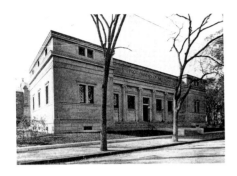

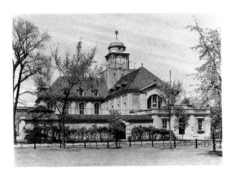

9. *The original Fogg Art Museum (opened 1895) prior to the addition made by Edward Forbes in 1910.*

10. *The Busch-Reisinger Museum, about 1940, when it was known as the Germanic Museum.*

Boston architect Richard Morris Hunt to build the William Hayes Fogg Art Museum.

Some suspected that the two men, having prior allegiance to the Museum of Fine Arts, "felt that in a city the size of Boston there was room only for one museum."[11] Norton himself first argued that the funds should be used to build up the Department of Fine Arts rather than a museum.[12] But the committee proceeded, constructing "a building with a lecture hall in which you could not hear, a gallery in which you could not see, working rooms in which you could not work, and a roof that leaked like a sieve."[13] Although the museum would abandon the inadequate structure in 1927 and it would later be torn down, Hooper and Brimmer could celebrate its opening in 1895 with this announcement in the *Harvard Graduate's Magazine*:

Higher education about important and well-recognized artistic facts is greatly needed, and it will always be welcomed by American students. That Harvard College is soon to have ready for use a well-fitted art laboratory, for the study and comparison of facts relating to art and artists, is a matter for hearty rejoicing.[14]

The inauguration of the "art laboratory" encouraged a fresh approach to art history. The movement that had begun with the founding of the Museum of Comparative Zoology gained momentum with the establishment of Harvard's Peabody Museum of American Ethnology and Archaeology in 1866 and Semitic Museum in 1890. The Fogg was not the only beneficiary of this impetus. The creation of these ethnological museums stimulated a group of German scholars at Harvard to propose a Germanic Museum to inculcate in undergraduates "a true conception of what Germany stands for in modern civilization."[15] Potentially a force for modernism, the museum was caught in an embarrassing political position when its first curator Kuno Francke claimed that it would also contribute "to the realization of the great Pan-Germanic alliance upon which rests the preservation of the Teutonic race's continued effectiveness in the struggle for world domination."[16] It would contribute significantly to the study of art history and to the presentation of modern art only after it came under the aegis of the Fogg in 1930.

Charles Moore served as the Fogg's first curator, then as its first director, until his retirement in 1909. His tenure was largely uneventful, in contrast to that of his successor, Edward Waldo Forbes, who together with Paul Sachs

would define the role of the university museum in America and play an important part in directing many of the nation's major art museums.

Grandson of Ralph Waldo Emerson and a Boston Brahmin, Forbes shared a background similar to that of his teacher, Charles Eliot Norton, but he was a strikingly different man. Gentle where Norton was acerbic, apparently dreamy where Norton was intense, Forbes was an amateur artist who spent his summers in search of the perfect oil glaze for his copy of a Florentine panel painting. Despite such otherworldly qualities and a sense of modesty that often obscured his achievements, he was an effective fund raiser and a collector of remarkable acuity. Forbes was inspired by Norton's classes to visit Italy after his graduation, where he made contact with Norton's son Richard, then director of the American Academy in Rome. The younger Norton encouraged Forbes to act on his growing admiration for the northern Italian painters, counseled him in his early purchases—and advised him to lend his works to the new Fogg Museum. When he was appointed director, Forbes was dismayed to find his loans the only works of artistic quality on view. The bulk of the display comprised dimly lit plaster casts and study photographs, several of the Gray engravings mounted in the print room, and a few pieces from Mrs. Fogg's bequest (Fig. 11).

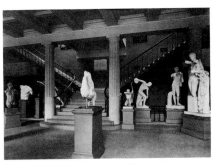

11. *Interior of the original Fogg Art Museum, showing the plaster casts of classical Greek sculpture that made up much of its early collection.*

Apart from a few Hudson River School and Luminist works and a major Albert Bierstadt, the Fogg bequest was hardly the basis of what Forbes hoped would become a center for the education and inspiration of younger generations. This disappointment was due in part to the fact that the bequest consisted of works by recent American painters, whom the Europe-worshiping connoisseurs of the time dismissed as marginal to the history of art. Thus Forbes, with his own private resources amounting to a few thousand dollars in discretionary income each year, together with help from his family, began to build the collection of his dreams, centered on what was for him the highest artistic achievement: Italian painting from the *Duecento* to the Renaissance.

For Forbes, "the study and comparison of facts relating to art and artists" was best facilitated by the photographs and slides that already formed a significant part of the study collections. The need for objects was chiefly to inspire, as Norton had inspired earlier generations.[17] The tradition of training the hand as well as the eye continued through courses in design given by the brilliant collector Denman Ross and, later, by Arthur Pope. The technical study of materials and facture, which held special importance for Forbes as a

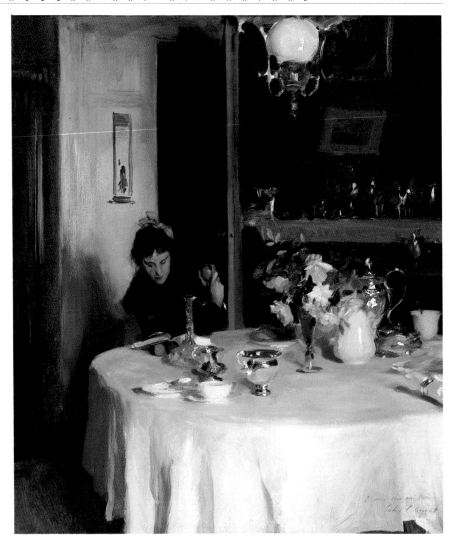

12. JOHN SINGER SARGENT
(1856–1925) American
The Breakfast Table *(1884). Oil on*
canvas. 55.5 x 46.4 cm. (21¾ x 18¼
in.). 1943.150. Bequest, Grenville L.
Winthrop.

This intimate picture of Sargent's
sister Violet was probably painted at
the home of the artist's parents in
Nice. Sargent displays his skill at
rendering still life in the sparkling
silver set and flowers on the table,
and he reveals his interest in Japa-
nese prints by depicting one on the
expanse of wall to the left. The artist
inscribed the work to his friend
Albert Besnard, a Parisian painter.

practicing artist, would be the third part of the comprehensive program in the history of art.

Although Forbes's interest in objects and his commitment to the technical analysis of art finally took him far from Charles Eliot Norton's methods, he retained the basic hierarchy of aesthetic values that Norton had established. For example, Norton had encouraged certain living artists, specifically, the Pre-Raphaelite Brotherhood in England and its American counterparts, whose search for the means of a sincere depiction of literary and religious subjects led them to idealize the work of Italian painters before Raphael and to reject the later art as false and mannered. But unlike some Boston collectors, who were acquiring works by the French Impressionists as early as the 1880s, Norton avoided innovative contemporary art that involved itself too deeply in the themes and issues of modern life. Indeed, one of the questions on his fine arts midterm exam asked: "Why are there no beautiful buildings in Chicago?" Obviously, the brilliant inventions of Louis Sullivan and the other pioneers of

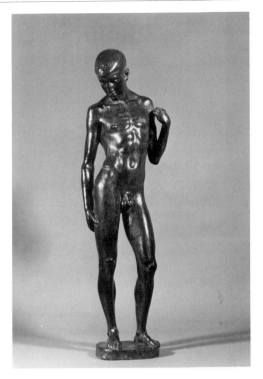

13. ARISTIDE MAILLOL
(1861–1944) French
Young Cyclist (c. 1908, cast c. 1925).
Bronze. Height: 96.5 cm. (38 in.).
1962.199. Purchase, Friends of the
Fogg and Alpheus Hyatt Funds.

The title of Maillol's bronze, his only free-standing male nude, derives from its subject, Gaston Colin, the athletic young chauffeur of Maillol's patron, Count Henry Kessler—Colin rode regularly to the artist's modeling sessions on a bicycle. The first cast of the work was exhibited at the 1909 Salon d'Automne, where it was admired by the great sculptor Auguste Rodin. Maillol was dissatisfied with this casting, however, and he had it recast in 1925. As the story goes, Count Kessler visited the foundry and enthusiastically seized the newly cast sculpture, carting it in triumph back to Maillol's studio. When the distraught foundry owner called to report that the sculpture had been taken, Maillol is reported to have said, "Fortunately, or else you would have ruined it with your file." Although the flowing simplicity of Young Cyclist's *line is characteristic of Maillol, the detail and portraitlike accuracy are unusual. The gangly grace of the youth's adolescent body seems to place the sculpture somewhere between Donatello's Renaissance masterpiece, the* David, *and Degas's arresting* Little Dancer, Fourteen Years Old *[fig. 48], which Maillol had probably seen at the 1881 Salon.*

modern architecture in America stirred Norton not at all. Forbes inherited enough of his teacher's taste to cause him difficulty with the more advanced art of his own contemporaries. As Meyer Schapiro has noted:

while an earlier generation of travelers had brought home works of Millet, Corot, Courbet, and Manet, the collectors in the 1890's and beginning of the new century turned more often to the past, ignoring or underestimating the best contemporary art. This was true especially of the cultivated heirs of old established fortunes. Reacting against American vulgarity, they lost touch with the vital elements in both European and American culture.... The more refined, those who set the standards, had absorbed something of the fervor of Ruskin and his American disciples, Jarves and Norton, and were drawn to Italian late medieval and Renaissance art.... The culture of these patricians was often broad, curious, and finely discerning, but it ignored the most vigorous contemporary ideas.[18]

Although Forbes was himself an artist and liked much current painting, he was apparently uncomfortable about exhibiting it. He could support the plans of others, as when he encouraged Arthur Pope to mount the first Degas exhibition in America, held at the Fogg in 1911, but these occasions were the exceptions that proved the rule. He summarized his position at a national museums meeting in 1911:

In the past, the policy of the Fogg museum has been to exhibit the work of men who are dead.... The difficulty is, first, that all modern art is not good, and we wish to maintain a high standard. In having exhibitions of the work of living men we may

14. CLAUDE MONET
(1840–1926) French
Fish (c. 1870). Oil on canvas. 35.6 x
50.3 cm. (14 x 19¾ in.). 1925.16.
Gift, Friends of the Fogg Art
Museum.

Monet painted with Pissarro on sev-
eral occasions during the year he
made this small composition of two
red mullets on a cloth. The work
seems to be a deliberate homage to
Edouard Manet, whose exquisite
still lifes of raw oysters, asparagus
spears, and peeled lemons are ren-
dered in a similarly delectable, pain-
terly way. The sensual painting and
delicate color harmonies elevate the
common mullets to gourmet status
—an achievement that Paul Sachs
and Edward Forbes acknowledged
by acquiring the painting in 1925.

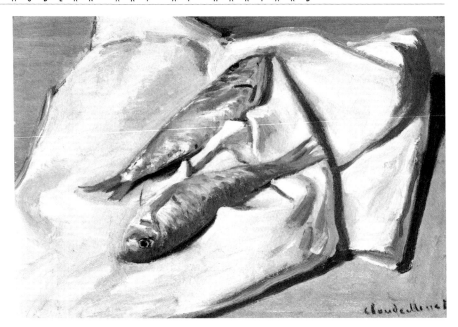

subject ourselves to various embarrassments. Artists sometimes have feelings. We do not wish to be always in hot water, and make ourselves unpopular by refusing them if we do not think their work up to our standard. If we attempt to discriminate between the good and bad art of today, people will say, "Judge not that ye not be judged."[19]

In 1916, Forbes again confronted his unwillingness to include contemporary art in the program, this time because of a donation to the Fogg. Edward D. Bettens, whom Forbes characterized as "obsessed with the idea of . . . buying pictures inexpensively from living artists," donated a handsome fund in honor of his mother, Louise, designated specifically for the purchase of contemporary American art.[20] Making the best of an awkward situation, Forbes acquired *Lake O'Hara* (Fig. 6), which had been painted by John Singer Sargent only months before. Forbes's comments in an article in the *Harvard Alumni Bulletin* of February 1917 more explicitly reveal his ambivalent attitude toward the acquisition of modern art—then simply defined as the work of living artists:

The acquisition of the Sargent landscape may make many people wonder why the Fogg Museum, after twenty-one years of existence, has now for the first time acquired a modern picture. In fact, I am told that many Harvard graduates ask the question: "Why does the Fogg Museum devote its main energy towards the acquisition of Italian primitive paintings? . . . Why buy early Italian pictures painted often by men who had no knowledge of anatomy, of perspective, of foreshortening, or of many of the painter's problems? Why not always buy works of modern men who understand these laws?" . . . The answer is the same to all of these questions. The importance of early Italian painting in the history of art is fundamental. The

paintings are not, as is so often supposed, merely curious and interesting histori-
cally. They are really beautiful, even though they sometimes need study before the
beauty is perceived.[21]

Not that Forbes's interests were limited to Italian art. He shared the Boston
aristocracy's enthusiasm for exotic cultures, a passion that had originated in
its clipper-ship trade with China and the Indies. His early acquisition of
Oriental art, Persian miniatures, and art from other non-Western traditions
paralleled the interests of such European progressives as André Salmon and
modern painters from James McNeill Whistler to Pablo Picasso. Yet Forbes's
interest in non-Western cultures did not persuade him to endorse the willful
distortions that his European contemporaries were appropriating for their art,
distortions that mark the rise of the modern movement.

When Forbes speaks of modern art in 1916, he is referring to such artists as
Sargent and Edgar Degas, whose technical proficiency preserved a sense of
continuity with the great traditions. The acclaim they had already received
made it possible for Forbes to accept their works for exhibition and acquisi-
tion. Forbes's concept of acceptable modern art did not include the work
exhibited in the Armory show, which had come to Boston in 1913, accompa-
nied by a blast of publicity from its previous New York and Chicago venues.
Indeed, there is no evidence that Forbes was affected by the Armory show—al-
though it is hard to believe that any artist or museum professional would have
missed it. Perhaps he had seen the strange and "epileptic" canvases of the
Cubists, Fauves, Orphists, and others, and simply did not know what to make
of them.

Toward the end of his life, when he reflected on the extent to which the
Victorian tastes of his youth had been replaced by the popular acceptance of
abstraction, Forbes mused on the differences between his training and the
tenets of his more modern colleagues: "I was brought up . . . to think of the
early mosaics and Cimabue and thirteenth century painting as crude begin-
nings. Then art rose through Giotto, Botticelli, Mantegna, to Michelangelo,
Rembrandt, and Velasquez, . . . then gradually went down through Fragonard
and Corot to more or less degradation in Picasso."[22] The acceptance of
modern art thus had an uneasy and tentative beginning at the Fogg, taking
place almost accidentally and even against the will of its visionary early
director. The radical ideas of such anti-Ruskinians as Roger Fry and Gertrude
Stein reached Harvard slowly, through the back door of connoisseurship and
the nascent modernism of Paul Sachs.

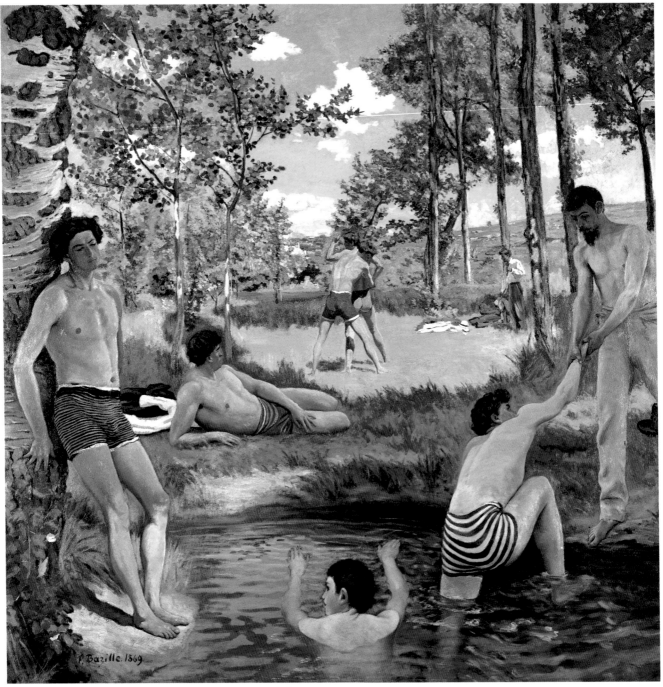

15. JEAN FRÉDÉRIC BAZILLE
(1841–1870) French
Scène d'été (Summer Scene,
Bathers), 1869. Oil on canvas.
158.1 x 158.75 cm. (62¼ x 62½ in.).
1937.78. Gift, Mr. and Mrs. F.
Meynier de Salinelles.

Like his friends Claude Monet and
Auguste Renoir, Bazille had long
cherished the hope of painting fig-

ures in a landscape, bathed in natu-
ral light. Bazille had modeled
for Claude Monet's outdoor compo-
sition Déjeuner sur l'herbe (1865–
66; since cut up and dispersed) and
had pursued his own efforts in the
years thereafter, culminating in the
summer of 1869, which he devoted to
the major composition, Summer
(continued on p. 32)

2 Gentlemen Collectors, Connoisseurship, and the Fine Arts in a Laboratory, 1915–1948

AMONG the most important acts of Edward Forbes's career was his 1915 appointment of Paul Joseph Sachs, first as assistant director of the Fogg, then as associate director. During their thirty-year joint rule, Forbes and Sachs gave life to the "art laboratory" envisioned by the museum's builders, and their influence extended far beyond Cambridge to the entire American museum profession.

Like Forbes, Sachs came from wealth and education, but of a markedly different sort. Artisans and schoolteachers in Europe, his family continued their trades and professions in New York, except for Paul's father, Samuel Sachs, and his mother's brother, Marcus Goldman, who together formed the international investment company Goldman Sachs. Paul was destined for a career in the family firm, but, like Forbes, he had studied fine arts as a Harvard undergraduate. His interest in the subject had been spurred by Charles Herbert Moore, then director of the Fogg, who was still teaching the Ruskinian principles of design considered crucial for understanding visual art. Students were required to make paintings and drawings themselves, duplicating the techniques of the old masters so that they would understand the difficulties of making art. Although Moore encouraged Sachs to pursue his studies in art history, Samuel Sachs did not approve, and the son found himself anxiously wondering how he was to go about selling bonds. His first lesson in investing came with the $750 his grandfather gave him for his twenty-first birthday. He promptly spent the money on prints by Dürer, Cranach, Rembrandt, Claude, and Turner. And despite his apprehension, Paul Sachs came to enjoy life in investment banking. He would allow himself the reward of an afternoon off after each successful sale, dedicating his entire commission to acquiring artworks. Perhaps a sign of quiet rebellion was the first painting that he purchased: a *Portrait of Ruskin* by Charles Herbert Moore, whose teaching assistant and protégé he might have been.

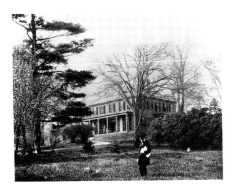

16. *Charles Eliot Norton on the lawn of Shady Hill, his home in Cambridge, about 1890.*

(continued from p. 30)
Scene. *Like Monet at the time, Bazille worked in the studio, using studies made from nature. The painting exemplifies the challenges confronting the Impressionists (as the painters would be dubbed in 1874) in their mixture of "plein air" realism with studio technique: the figures, executed with care and precision, are not fully integrated with the landscape, which is handled vigorously and with great freshness. The painting's overall composition is unified by the foreground swimmer and the background wrestlers who lock the sections rigidly together. The work proved a success at the Salon of 1870, prompting Bazille to write to his parents:* "I am delighted with my exhibition. . . . Everybody sees [my painting] and talks about it. Often more bad than good is said of it, but at least I'm in the swim and whatever I shall show from now on will be noticed." *Bazille was killed in the Franco-Prussian War on November 28, 1870, only months after* Summer Scene *had initiated his public career.*

Through collecting, Sachs became friendly with a whole world of lawyers, bankers, and other "gentlemen collectors" who haunted galleries after hours, during lunchtime, or even en route to meetings. On a certain occasion, one of these friends, the lawyer William Ivins, Jr. (whom Sachs would later recommend for the job as print curator at the Metropolitan Museum of Art in New York), asked him to define what constituted a good drawing. The question prompted Sachs to realize that, for him, the basis for judging quality lay in an emotional understanding of the artist's message:

where there is what is called *technique* and technique only, there is really nothing at all. It is as if one asserted that a man writes beautifully, but unfortunately had nothing to say. . . . Mere logical accumulation of detail never yet showed anything but assiduity and patience—two moral qualities that should not be allowed for a moment to influence our judgement of the artistic expressional fact.[1]

Sachs's collecting activities were well known to Edward Forbes, who invited him to become a member of the museum's Visiting Committee in 1911. Two years later, Sachs was appointed chairman of the committee. Over lunch, Forbes had turned to Sachs and impulsively asked, "When are you going to join us here?" It was only afterward that Forbes secured President Lowell's approval to make the offer, which Sachs accepted. In preparation for this new, unsalaried, and largely undefined position, Sachs left investment banking and embarked on a five-month tour of museums across the country. In the fall of 1915, at Forbes's suggestion, he moved his family to Shady Hill, the large house that would always be associated with its legendary former occupant, Charles Eliot Norton (Fig. 16).[2] This was an important symbolic act: distinguished art historians, artists, and other eminent visitors to Cambridge had always stayed at Shady Hill. With the gregarious Sachs in place, it was assured that the tradition would continue. Here, too, students and colleagues would gather to discuss issues of attribution and connoisseurship, issues applied directly to the expanding collections of their host.

Sachs was soon asked to give courses on the history of prints, the history of French painting, and other topics. Made a full professor in 1927, he seems to have remained insecure about his academic qualifications. His lectures were always read, never improvised, and he labored over the accuracy of his facts and interpretations. Nevertheless, confidence in objects never left him. Agnes Mongan, Sachs's first assistant (and later drawings curator and Fogg director), recalls that he was reading from his "script" on Cézanne during one lecture

and happened to look up from the lectern. Seeing the slide of a magnificent painting projected behind him, he gasped, put down his text, and exclaimed, "Look at it! Just look at it!"[3]

As this incident suggests, Sachs was more sympathetic to the modern movement than Forbes was, yet the two men had great respect for each other's abilities, and their ideas for the museum's future were closely intertwined. Sachs praised Forbes for making the Fogg "not only a treasure house, but also a well-equipped setting adapted for teaching purposes.... he meant it to be a workshop as well as a place of inspiration for undergraduates and mature scholars. Free from the craze for size, uncompromising when it came to quality, Forbes was bending every effort to acquire works of art by purchase or loan,... for he understood sooner than others the importance of confronting students with original works of art rather than the usual photographic material. In 1909, that was still a novelty."[4]

17. *Paul Sachs, with students of his last museum course, in the Naumburg Room at the Fogg Art Museum, 1943 or 1944.*

Perhaps because of his background in investment banking, Sachs was quick to analyze the future needs and developments of art history education. He saw that World War I marked the actual terminus of the nineteenth century and realized that the twentieth called for a new kind of art historian. Sachs's "museum course," as it was known, was designed specifically to train those who would handle and interpret the stream of objects flowing from private hands into public art museums, a stream "sure to swell after World War I." "Why not," he asked, "use our unique facilities to train qualified men and women in the graduate school not only to be teachers, but also to play their part as curators and directors of Museums throughout the country?"[5]

Sachs saw such training as a "new challenge," not merely personal or professional, but institutional and, ultimately, national. He had predicted that "not later than the mid '20s, an insistent call would be heard for trained museum men. Harvard must get ready to assume leadership in such a developing profession, the dignity of which was then but imperfectly understood." The dignity of the profession would be ensured only by training in a well-equipped laboratory. The brochure that Forbes and Sachs wrote to describe the department, titled *The Fine Arts in a Laboratory*, hearkened directly to the progressive goals of President Eliot and to the earliest hopes of the museum's builders. The laboratory was a generalized liberal ideal, but it also described Forbes's concrete and pioneering achievement in establishing conservation as an essential part of a museum.[6]

In Sachs's mind, future museum scholars would also need training to

18. JOHN MARIN
(1870–1953) American
Trinity Church, New York *(1911).*
Watercolor over graphite on paper.
22.8 x 18.8 cm. (8⅞ x 7⅜ in.).
1948.39. Gift, Meta and Paul J.
Sachs.

During a five-year stay in Europe,
New Jersey-born John Marin met
Edward Steichen, the photographer
who worked closely with Alfred
Stieglitz in founding the New York
avant-garde gallery "291." Steichen
sent several of Marin's unusual wa-
tercolors to Stieglitz, who exhibited
them at the gallery in 1909. The
show was so successful that, when
Marin returned to New York in 1910,
he was already acknowledged as an
important talent. He settled in the
city, painting scenes like Trinity
Church, New York. *He described his*
work in a letter to Alfred Stieglitz as
"piling New York's great houses one
upon another with paint as they do
pile themselves up there so beautiful,
so fantastic."

reinforce their "broad human sympathies, including a belief in popular education." He felt that "in the twentieth century in America a museum should be not only a treasure house, but also an educational institution." In a statement issued at the beginning of American involvement in World War II, when he became chairman of a wartime committee whose job was to identify priorities for the protection of cultural property, Sachs and his colleagues declared that "Art is . . . the visible evidence of the activity of free minds, . . . an expression of the higher values of life, [and] an undeniable factor in a free people's resistance." This was in keeping with Sachs's strong feeling that the power of art was essentially democratic, and that art museums should eschew elitism in favor of "the vital and practical interest of the working millions."[7] Although Harvard itself could never directly serve these millions, it could train those who would, and the view of modern art that emerged from the Fogg

19. JOHN MARIN

(1870–1953) American
Mount Chocorua, *1926. Watercolor
and charcoal on paper. 43.8 x 55.9
cm. (17¼ x 22 in.). 1928.5. Pur-
chase, William M. Prichard Memo-
rial Fund.*

The fact that Mount Chocorua *was
acquired by the Fogg a scarce two
years after its execution attests to
Marin's growing importance in the
artistic circles of the time. Marin fell
in love with New England after a
visit to Maine in 1914 and often re-
turned there from New York to paint*
*energetic watercolors depicting its
natural beauty. He painted this wa-
tercolor on a trip through Vermont
and New Hampshire in July 1926.
The characteristically fresh, confi-
dently applied patches of color in the
sky are punctuated by thrusting tree
branches that add to the work's com-
positional tension. Marin continued
to pursue the traditional American
theme of the grand landscape, but
according to his own modern vision
and innovative style, stimulated by
contacts with Cubism at Alfred
Stieglitz's pioneering gallery, "291."*

20. CHARLES SHEELER
(1883–1965) American
Totems in Steel, *1935. Conté crayon
and graphite on paper. 48.5 x 57.7
cm. (19⅛ x 22¾ in.). 1965.148. Be-
quest, Meta and Paul J. Sachs.*

*Greatly impressed by the careful en-
gineering he perceived in the work of
Piero della Francesca, the fifteenth-
century master, Sheeler began in
1929 to conceive of his own works as
architectural wholes. In its intricate,
precise, mechanical geometries,*
Totems in Steel *exemplifies this
approach.*

Museum in the period between the wars was widely promulgated through this popularizing spirit.

Sachs's view of modern art was built upon the yearning for "uplifting" content and spiritual values that had characterized Norton's and Moore's approach. Sachs, however, placed a greater emphasis on connoisseurship: the informed discrimination among styles, artists, and objects of greater and lesser quality; the exquisite refinement of taste. As Sachs conceived connoisseurship, quality could be judged within almost any artistic style (even modern movements), as long as the work of art in question pursued a recognizable goal and shared a sufficient number of techniques or media with traditional artworks. This prevented his appreciating some modern art, but it was a great advance over the outright narrow-mindedness of his predecessors. Nor was Sachs pedantic in his reliance on accepted traditional works as the standards by which to judge the new. For, as he noted in his memoirs, the meaning of connoisseurship derives from the French *connaître*, "to *know by the senses*." Thus the training of connoisseurs must emphasize the *sensibilité*. This called for exposure to original art works of the highest quality in addition to the requirements of solid scholarship. The true connoisseur would combine this scholarship with "instinct [and] *sensibilité*."[8]

Underlying all aspects of Sachs's museum training program, in addition to the ideal of "solid scholarship," was a passion for the work of art itself, a commitment already established by Forbes in the first few years of his directorship. Sachs endorsed Forbes's vision of the object's role in teaching,

21. EDWARD HOPPER

(1882–1967) American
Cold Storage Plant *(1933). Water-
color over graphite on paper. 49.7 x
62.4 cm. (19½ x 24½ in.). 1934.62.
Purchase, Louise E. Bettens Fund.*

*Edward Hopper, a student of Robert
Henri, labored in obscurity until he
began to paint watercolors in 1923.
At that time, a New York dealer
named Frank Rehn exhibited
Hopper's watercolors in a show that
launched the artist's career; by 1926
he was acknowledged as one of the
foremost American painters.
Hopper's masterful exploitation of
watercolor is evident in this fresh,
thoughtfully rendered composition.
Taking as his theme a harsh archi-
tectural form, the artist painted it
straightforwardly, but the brushy
quality of the edges created by the
textured paper, and the luminosity of
the paint, soften the explicit coldness
of the subject. As Hopper himself de-
clared, "My aim in painting has
always been the most exact tran-
scription possible of my most inti-
mate impressions of nature."*

22. HENRI MATISSE

(1869–1954) French
Lady with a Necklace, *1936. Pen
and ink on paper. 54 x 45 cm. (21¼
x 17¾ in.). 1965.307. Bequest, Meta
and Paul J. Sachs.*

Lady with a Necklace *is one of a
series of ink drawings begun in 1935
and published in a special edition
by* Cahiers d'Art *the next year.
A new Russian model, Lydia
Delectorskaya, inspired Matisse,
whose enjoyment of her Balkan
blouse and her "plastic splendor"
animate his exuberant drawings.
Unlike such Fauvist woodcuts as*
Seated Nude *(fig. 26), in which line
is of a uniform density and a nearly
uniform texture, Matisse's line in*
Lady with a Necklace *describes con-
tours, creates color, and forms sche-
matic signs for the model's nose and
eyebrows.*

23. CHARLES SHEELER
(1883–1965) American
Upper Deck, *1929. Oil on canvas.*
74 x 56.2 cm. (29⅛ x 22⅛ in.).
1933.97. Purchase, Louise E. Bettens
Fund.

An example of Sheeler's early explo-
ration of mechanical subjects, Upper
Deck *is one of the Fogg's best-known*
paintings. Sheeler, who had become
a professional photographer in 1912,
painted this canvas directly from a
photograph taken in 1928. His Pre-
cisionist manner, in which he sim-
plified and angularized form,
eliminating surface detail, was con-
sidered very daring for a Fogg ac-
quisition. In a 1933 letter to
Sheeler's dealer, Edith Halpert,
Edward Forbes wrote: "I like the pic-
ture very much indeed and am glad
to have it in our museum. As it is so
unlike all our other pictures, it will
be a little hard to exhibit."

particularly his belief in its capacity to inspire: "intimate contact with objects develops powers of discrimination and understanding; is an aid in moulding taste; gives students who later turn to industrial or professional pursuits a realization that in addition to illuminating history and literature, the value of art lies *also* in its appeal to the emotions." Yet for Sachs, the appeal to the emotions had to be modern and direct, as against Norton's approach, which "left students with a literary appreciation of the old masters rather than an appreciation of their works." Sachs sought the rigor of science and rejected the ineluctable claims of literature. In a letter praising his program, Sachs's longtime correspondent Bernard Berenson warned of the potential dangers of an academic environment, echoing Sachs's own criticism of the literary approach: "Your training is sensible. . . . It will not be if you should ever take

24. MAURICE PRENDERGAST
(1861–1924) American
Beach, New England *(1920). Water-*
color over graphite on paper. 38.7 x
56.2 cm. (15¼ x 22⅛ in.). 1961.137.
Gift, Mrs. Charles Prendergast.

Acquired by the Fogg directly from
the widow of the artist's brother,
Charles, this scintillating watercolor
is typical of the technique and
themes that placed Prendergast in
the forefront of early modernism in
America. Although he allied himself
initially with the Ash Can School,
painters named for their gritty
urban themes rendered in dark, dra-
matic tones, Prendergast was ob-
viously an anomaly in the group.
The artist was masterful in his
method of interspersing strokes of
pure color with tiny areas of white
paper, creating the vibrant, shim-
mering mosaic effect evident in this
beach scene.

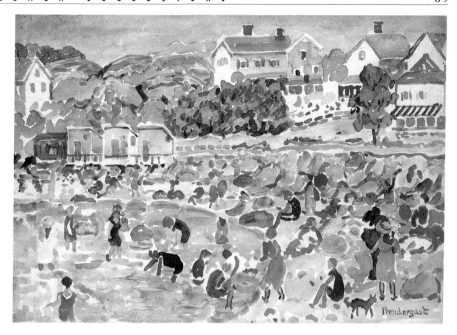

25. CHARLES DEMUTH
(1883–1935) American
Fruit and Sunflowers, *1924. Water-*
color over graphite on paper. 45.7 x
29.7 cm. (18¼ x 11¾ in.). 1925.5.3.
Purchase, Louise E. Bettens Fund.

A master watercolorist, Charles
Demuth studied with the Philadel-
phia Realist Thomas Anschutz and
the American Impressionist William
Merritt Chase before making several
trips to Europe around 1910, where
he evolved a more cosmopolitan
style. Fruit and Sunflowers *exempli-*
fies Demuth's brilliant translation
of Cubist theory into an ordered spa-
tial system that gives body and so-
lidity to forms rather than dissolv-
ing them. Also evident is Demuth's
intuitive use of color, which he ex-
pressed most brilliantly in water-
color. Acquiring this work very soon
after its execution, the Fogg became
one of the first major institutions to
recognize Demuth's achievement in
the medium.

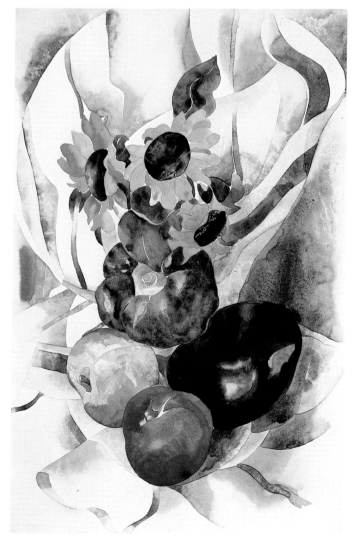

26. HENRI MATISSE
(1869–1954) French
Seated Nude *(1906). Woodcut. 57.2
x 46 cm. (22½ x 18⅛ in.). M13,022.
Purchase, Francis Burr and Alpheus
Hyatt Funds.*

*Around 1906, Ambroise Vollard
reportedly asked Matisse to help
him pull prints from woodblocks
Gauguin had sent from Tahiti.
Matisse was inspired by the ancient
printing technique and made three
woodblock prints himself, including*
Seated Nude, *for his second one-
man show at the Galerie Druet. Un-
like other artists who were similarly
inspired (both the Fauves and the
Brücke artists began to make wood-
cuts at about this time), Matisse did
not gouge the block himself, but left
this task to Mme. Matisse, an arti-
san of great skill, who transferred
his drawing to the block and care-
fully cut it. The image of* Seated
Nude, *with its Fauvist dynamic of
bold, energetic lines that oscillate
around the woman's body, was exe-
cuted in two sizes, of which this is
the larger, more willful, and vigor-
ous version.*

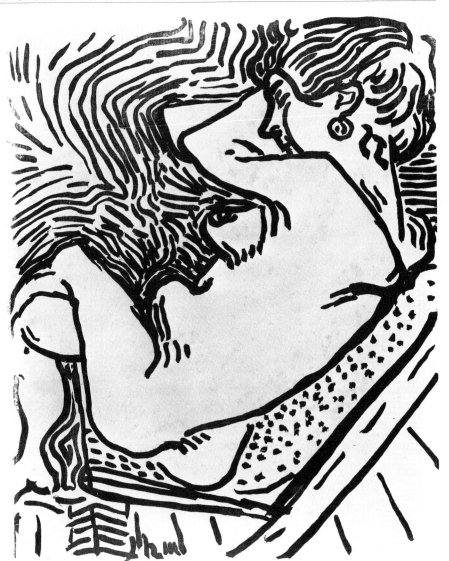

into your midst spell-binders whose main tendency might be to turn art into literature, riding over the infinitely painful learning of form as pure form and feeding students with information utterly irrelevant to the real problems of art."[9]

By "form as pure form" Berenson was not referring to the work of the Cubists or other experimentalists, who were pushing form away from representational realism toward a new kind of abstract signification. And despite Sachs's more modern approach to the artworks, it is clear from the 4,702 objects in the Paul and Meta Sachs Bequest that nonobjective art did not much interest him. The Sachses collected works of exceptional quality in fields ranging from ancient, to Oriental, to European Old Masters, and to French art from Impressionism to the School of Paris. Yet in this highly catholic selection, there are but few works that could be called nonobjective, and, of these, many were late acquisitions made to fill gaps in the museum's collection. Sachs's

taste leaned to the classic: Matisse line drawings, the classicizing drawings of Picasso, an enigmatic Khmer head. While he ventured occasionally into such abstracting works as John Marin's *Trinity Church, New York* (Fig. 18), or Charles Sheeler's *Totems in Steel* (Fig. 20), he seems not to have collected the works of more radical abstract artists such as Lissitzky, Malevich, or even Kandinsky, although he encouraged others to do so.

27. *Fogg Art Museum, shortly after opening in 1927.*

More characteristic of his eye is Matisse's masterful *Lady with a Necklace* (Fig. 22), purchased only months after its execution and later given to the Fogg. Matisse declared that his line drawings, more finished than the pencil or charcoal studies that preceded them, were "the purest and most direct translation of my emotion.... They generate light; ... they contain ... quality and sensibility."[10] Few attributes are more appropriate for a Sachs acquisition than emotion, light, quality, and sensibility—in perfect balance. Other graphics in Matisse's oeuvre may emphasize one of these attributes over another—his charcoal sketches, for example, are laden with expressive *pentimenti* and have their own emotional timbre; the woodcut *Seated Nude* (not a Sachs gift; Fig. 26) presents dense rhythms and an almost shocking use of black—but in *Lady with a Necklace*, the qualities Matisse celebrated are exquisitely balanced, and must have spoken to Sachs with a special voice.

Sachs's ambivalence toward more assertively innovative modern art was partly a generational bias. It is a rare collector who can empathize with the efforts of artists younger than himself. But partly also it was a reflection of Sachs's sensitivity to the needs of a university museum; for he formed his personal collection with the ultimate purpose of transferring it to the Fogg. He had tremendous admiration for the work of his protégé Alfred Barr at The Museum of Modern Art, who had "helped people to *see*."[11] Yet he seems to have deferred to Forbes's conviction that a university museum must be more circumspect in its endorsement of the work of living artists. Better to let scholars and art historians determine conclusively that artists have achieved "classic" status before incorporating them in a teaching program; better to see how their stories end before risking an exhibition or defining a new movement.[12]

If Sachs was wary about *acquiring* the work of living artists for the Fogg, he was willing to take risks with *temporary* exhibitions. As he and Forbes began to plan in the 1920s for the new building that the Fogg so desperately needed— for the service of the nation, as the campaign statement emphasized—Sachs worked quietly to obtain space for temporary exhibitions that would incorpo-

28. MARSDEN HARTLEY
(1877–1943) American
Landscape *(c. 1910). Oil on board.
29.2 x 29.2 cm. (11½ x 11½ in.).
1958.304. Gift, James N. Rosenberg.*

*In July 1910 Hartley wrote to his
niece, Norma Berger: "I do not
sketch much these days for I work
almost wholly from the imagination
...using the mountains only as
background for ideas." These four
small paintings are examples of this
working method. As a young artist,
Hartley believed that divinity is
manifested in nature, and he saw
the American mystical painter,
Albert Pinkham Ryder, as a role
model. Ryder's spiritual approach to
painting justified Hartley's own vi-
sion of the natural world. These
densely painted, richly colored ren-
ditions of mountains in Hartley's
native Maine are evidence of the
artist's sensitivity to the overwhelm-
ing power of nature. This is most
strongly expressed in* Kezar Lake,
Autumn Morning, *which depicts
small forms dwarfed at the foot of
the darkly layered mountains.*

29. MARSDEN HARTLEY
Composition *(1910). Oil on board.
29.2 x 29.2 cm. (11½ x 11½ in.).
1958.305. Gift, James N. Rosenberg.*

30. MARSDEN HARTLEY
Kezar Lake, Autumn Evening
(c. 1910). Oil on board. 30 x 30 cm.
(11⅞ x 11⅞ in.). 1967.43. Bequest,
Lee Simonson.

31. MARSDEN HARTLEY
Kezar Lake, Autumn Morning
(1910). Oil on board. 30 x 30 cm.
(11⅞ x 11⅞ in.). 1967.42. Bequest,
Lee Simonson.

rate modern art into the program: "I stood alone in believing that controversial modern works of art ought also to be shown, if not actually purchased. It seemed to me important to have the Fogg, as a living museum, offer the students contact with the artistic production of our time—the world of actuality."[13] What Sachs meant by "controversial modern works of art" can perhaps be inferred from the living artists represented in his own collection: Ben Shahn, Raphael Soyer, Eugene Speicher, Max Weber, Jack Levine, Henry Moore. If not always "classic," the work of these artists is usually figurative, and the pieces in Sachs's collection are almost exclusively so. The controversy resulted solely from the fact that the artists were still alive, and, therefore, not yet assessed by art history.

Sachs was unable to realize his hopes for a program of controversial modern art at the Fogg, but he did achieve some innovative installations in the new Fogg building. Borrowing works from Harvard's Peabody Museum of Ethnography and Archaeology, he installed a gallery of Maya works and other "primitive" art, which remained on view until his retirement. It was the first permanent installation in any museum to present this work as *art* rather than ethnographic artifact.[14] The record also shows that he encouraged the endeavors of others to promote contemporary art. If he could not present it at his own institution, he generously provided financial and moral support for activities elsewhere. An early example was the short but extraordinary career of the Harvard Society for Contemporary Art.

In the winter of 1928, almost a year before the founding of The Museum of Modern Art in New York, an undergraduate fine arts student complained to Sachs about the Fogg's inactivity in contemporary art. Sachs responded sympathetically. Knowing that Forbes would not agree to extend the museum's resources, particularly into this dangerous area, he encouraged the student to organize. By February 1929, the young man—whose name was Lincoln Kirstein—had gathered a few friends and created a board that was incorporated as the Harvard Society of Contemporary Art. The trustees were Forbes, Sachs, John Nicholas Brown, Philip Hofer, Arthur Pope, Felix M. Warburg, and Sachs's brother Arthur; later added was A. Conger Goodyear, president of The Museum of Modern Art (where Kirstein would work briefly after graduation, before meeting George Balanchine and founding the School of American Ballet). The other undergraduate directors were John Walker III and Edward M. M. Warburg, with Sophia Ames serving as secretary.

The society's first season of exhibitions and events, punctuated by the stock

market crash, was presented in rooms rented from the Harvard Cooperative Store. Alexander Calder rode up on the train from New York with a reel of bailing wire and some clippers to create his first "circus." A supplement to Sachs's Fogg exhibition on the School of Paris was staged with loans from Lizzie Bliss (one of The Museum of Modern Art's founders) and others, and Buckminster Fuller staged an exhilarating one-man demonstration of his "machine for living," the Dymaxion House.[15] Subsequent years saw a return of the energetic Fuller, such exhibitions as "Contemporary German Painting and Sculpture," "International Photography," "Architecture and Interiors," "Surréalisme," "Abstraction"—and the first comprehensive exhibition in America of paintings, objects, and architectural photographs documenting the Staatliches Bauhaus in Dessau. The photographs had been lent by Philip Johnson, then a Harvard undergraduate.

The society lasted until 1936, when hard times forced its meager $6,000 annual budget into foreclosure. Ironically, the last undergraduate director, whose dismal job it was to preside over the disbursement of the net assets (stationery, some gallery furniture, and an antique typewriter of monolithic proportions), was the young John Coolidge, who would later play such an important role in bringing contemporary art to Harvard.

The twenties and thirties witnessed other fateful events in the career of modern art at Harvard. Sachs had been asked by friends in Cincinnati to look after a young graduate student named Charles Kuhn, who was studying the Catalan Romanesque. The two men became regular correspondents, and Kuhn did occasional research on works that Sachs or the Fogg might want to acquire. When, in the late twenties, Germanic Museum curator Kuno Francke fell ill, the university asked Sachs to serve as administrator. In 1930, President Lowell determined that the building and its collection of casts and reproductions should be permanently shifted to the Fogg's jurisdiction, and Sachs suggested Kuhn for the curatorship.

Despite his lack of experience in Germanic studies, Kuhn became an extraordinary curator, purging the museum of its Teutonic nationalism as he brought it into the twentieth century. The first and most profound change was his decision to acquire original artworks. The nonarchitectural casts were sold or put into storage in favor of temporary exhibitions, and on his first trip to Germany as curator he acquired Rudolf Belling's *Portrait of Alfred Flechtheim* (Fig. 32). Flechtheim, a Berlin art dealer and an important patron of many avant-garde artists, gave Belling's portrait of himself to Kuhn as a memento of

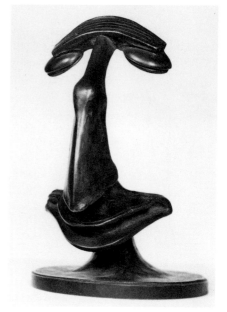

32. RUDOLF BELLING
(1886–1972) German
Portrait of Alfred Flechtheim, *1927.
Bronze. Height: 19.1 cm. (7½ in.).
BR 1931.75. Gift, Alfred Flechtheim.*

In Belling's oeuvre, there is nothing else quite like the Portrait of Alfred Flechtheim. *Ten known casts of this small portrait exist, indicating that Belling valued it as much as his better-known works, which were produced in smaller editions. The ideas of the Constructivists and artists of the Dutch de Stijl group had a great impact on Belling in Berlin during the 1920s, as did the work of the Italian Futurist Umberto Boccioni. But while the Flechtheim portrait shares the penetrated solids and open forms of Belling's Futurist works, it is closer in spirit to the caricatural impulse found in earlier works by Expressionists and painters of the "Neue Sachlichkeit" ("new objectivity"). This is in keeping with Flechtheim's role as a champion of such painters as Otto Dix, whose own portrait of the influential art dealer exhibits a similar satirical insight into Flechtheim's physiognomy.*

33. FRANZ MARC
(1880–1916) German
Playing Dogs *(c. 1912). Tempera on*
board. 38.1 x 54.6 cm. (15 x 21½
in.). BR1950.451. Purchase.

In contrast to the Cubists in France,
the members of the Blaue Reiter
movement in Germany, which Marc
founded with Wassily Kandinsky in
1911, practiced an abstraction filled
with symbolic content. Marc's use of
colors as symbols for spiritual and
psychological concepts (blue, for ex-
ample, corresponded with male-
ness and spirituality) grew from
Kandinsky's color theories. By repre-
senting human longing in the rest-
less action of animals—dogs, as in
this powerful canvas, or often in the
noble form of horses—Marc sought to
objectify the suffering and longing of
humanity and to suggest a spiritual
union among all living beings.

34. MAX BECKMANN
(1884–1950) German
Self-Portrait in Tuxedo, *1927. Oil*
on canvas. 138.4 x 95.9 cm. (54½ x
37¾ in.). BR1941.37. Purchase.

Beckmann's magisterial Self-
Portrait in Tuxedo celebrated and
consummated the artist's success in
Weimar Germany. Only a year after
its execution, it was purchased by
the Berlin National Gallery, where it
became one of Beckmann's most pop-
ular works. Little more than a dec-
ade later it fell victim to its previous
celebrity in the "degenerate" Weimar
period, as the Nazis purged it from
the museum.

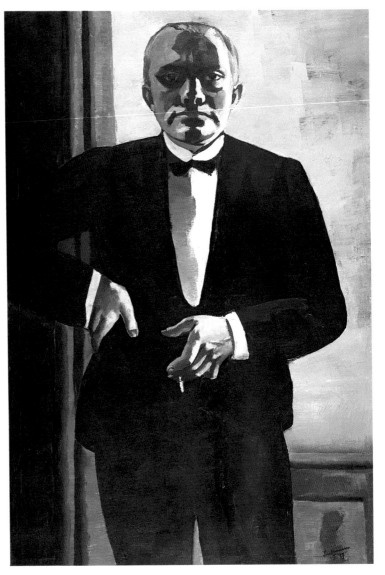

their visit. With the rise of National Socialism, such visits and such generosity became increasingly difficult: Flechtheim was a Jew. It became Kuhn's policy "to show the art of as many refugees as possible, almost regardless of quality!"[16] This comment's facetiousness (it was made long after the war years) should not obscure the fact that Kuhn exhibited such important artists as Käthe Kollwitz (1933); Georg Grosz (1935); Otto Dix (1936); Lyonel Feininger (1938); Paul Klee, Mies van der Rohe, Max Beckmann (1940); Franz Marc (1941); and many others well before they had become well known. Early on, he collected prints and other inexpensive works by living artists as well as contemporary decorative arts—typography, posters, and glassware from a range of international sources.

Kuhn's contacts from his trips to Germany before the war enabled him to make later acquisitions of even greater importance. His friendship with Curt

Valentin, the German dealer who salvaged much from the infamous Nazi purges of "degenerate"—i.e., modern—art, gave him the opportunity to purchase Max Beckmann's magisterial *Self-Portrait in Tuxedo* (for $400 in 1941; Fig. 34) and, when Valentin could bear to part with it, Erich Heckel's triptych *To the Convalescent Woman* (Fig. 35). Both formerly owned by major German museums, they are arguably among the finest works of these painters.

Throughout the thirties and forties, Kuhn labored to make the study of northern European art central to the Harvard program. His efforts were thwarted by his museum's small endowment and the disruptions of the war years, when the building was occupied, symbolically enough, by the U.S. Army School of Chaplains. Kuhn's most significant acquisitions would not be made until the 1950s, when a gift from Emdee Busch-Greenough gave the Germanic Museum new life as the Busch-Reisinger Museum of Central and Northern European Art.

Other former Harvard students who had an impact on the study of modern art include Henry-Russell Hitchcock and Philip Johnson; they revolutionized American architecture with their traveling exhibition for The Museum of Modern Art introducing the "International Style." Their friend from the Fogg, A. Everett ("Chick") Austin, Forbes's former staff assistant, became the new director of the Wadsworth Atheneum and transformed one of the oldest American art museums into the newest with the 1934 opening of the Avery wing. Striving for the "hovering horizontals" and smooth planes of the

35. ERICH HECKEL
(1883–1970) German
To the Convalescent Woman *(1912-13). Oil on canvas. Triptych, each panel: 81.3 x 70.8 cm. (32 x 27⅞ in.). BR1950.415. Purchase, Edmee Busch Greenough Fund.*

After Heckel moved from Dresden to Berlin in 1911, his colors became softer and their harmonies more subtle. Line also served a new function, no longer indicating contour alone but creating shadow and pattern as well. To the Convalescent Woman, *which shows the artist's young wife surrounded by flowers and by Heckel's own wood carvings, represents a high point in German Expressionist art. The search for vitality and direct emotion, symbolized for the Expressionists by African art, is demonstrated by the "primitive" aspect of Heckel's carvings and by the Ashanti wall hanging he has depicted in the background of the triptych.*

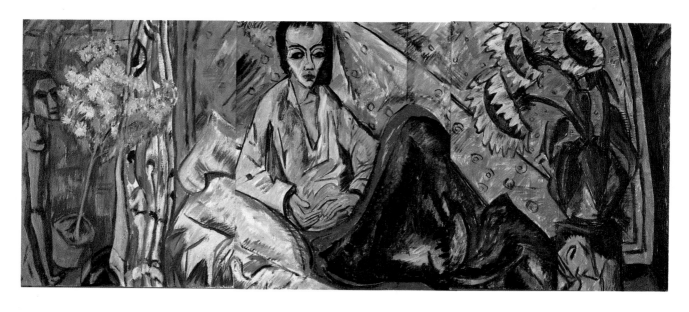

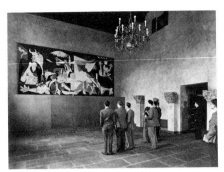

36. *Pablo Picasso's* Guernica *(1937; Prado, Madrid), displayed in Warburg Hall at the Fogg Art Museum, 1941.*

International Style, the new addition included an atrium that echoed—in a modern idiom—the Fogg's own Renaissance courtyard. Opening with a ground-breaking Picasso exhibition and the world premiere of the Gertrude Stein/Virgil Thomson opera *Four Saints in Three Acts*, Chick Austin's museum "forced modernity on New England for good and all."[17]

Austin's modernism and the Stein/Thomson opera earned Hartford the nickname of "the new Athens" and had a catalytic effect on Boston's envious modernists. As Agnes Mongan tells it, groups of Boston cognoscenti went down for the glittering opening; on the drive back, an inspired Nathaniel Saltonstall (a Boston architect and a trustee of the Museum of Fine Arts) said, "Agnes, why can't Boston do something about contemporary art?" As Paul Sachs had responded to Lincoln Kirstein a few years earlier, she advised Nat to organize.[18]

He started by forming a Boston branch of New York's Museum of Modern Art, but in 1939 Saltonstall's new organization changed its name to the Institute of Modern Art and, later still (1948), to the Institute of Contemporary Art (ICA). Sachs and Mongan were early members of the board, and James Sachs Plaut, a nephew and former student of Sachs, became its first director. Jim Plaut had joined the staff at Boston's Museum of Fine Arts after graduating in 1933, only to find that the museum was still enforcing its self-imposed policy against acquiring or even exhibiting the work of living artists. Given the chance to direct the new institute, Plaut left immediately to take up the position he would hold for twenty years.

The relationship between the Harvard art museums and the ICA began with its very first exhibition, a Gauguin show, in May 1936. Organized for the new museum by the Wildenstein Gallery, it was held at the Fogg. Plaut (then still at the Museum of Fine Arts) bought one of the greatest paintings, *D'ou venons nous? (Where do we come from?)* right out of the show for his own museum. Other exhibitions were held at the Germanic Museum—such as "Contemporary American Sculpture" (1937). Once the Institute had its own facility, exhibitions were shared between Harvard and the ICA. These included "Edvard Munch" (1950), with an important catalogue by Harvard professor Frederick Deknatel; "Walter Gropius" (1952); and "J.C. Orozco" (1953). Paul Sachs was a frequent lender and backer of the Institute's programs.

Through his ties to the Museum of Modern Art in New York, Sachs kept in touch with scholarship of the modern movements and later wrote *Modern*

37. EDOUARD MANET
(1832–1883) French
Study of a Blond Man *(c. 1880).*
Pastel on canvas. 63.3 x 34 cm.
(21 x 13⅜ in.). 1934.36. Bequest,
Mrs. Annie Swan Coburn.

According to John Rewald's Edouard
Manet Pastels, *this swiftly rendered
yet richly suggestive sketch is a por-
trait of George Moore, whom Manet
also portrayed in oil. Completed
near the close of his career,* Study of

a Blond Man *was executed in a de-
manding medium well suited to the
sure-handed confidence Manet had
developed in his Impressionist
works. The works of this artist,
whose lively, loose brushwork of the
period has its counterpart here in
pastel, form a transition between
the Realists of the early nineteenth
century and the French Impression-
ists. By 1880 Manet had partially
identified himself with the latter
group, exhibiting with them in Paris.*

38. PABLO PICASSO
(1881–1973) Spanish
Man with a Pipe *(1911). Black chalk
and gray oil wash on paper. 64.2 x
46.7 cm. (25¼ x 18⅜ in.). 1952.35.
Purchase, Annie Swan Coburn Fund.*

Man with a Pipe *was the first ana-
lytic Cubist drawing to enter the mu-
seum's collection, filling one of its
most serious gaps and documenting
a crucial period in twentieth-
century art. Produced during a soli-
tary summer at Céret, France,* Man
with a Pipe *sustains Picasso's tenu-
ous balance between total abstrac-
tion and representational illusion.
The pipe is represented at mid right
through the four holes perforating
its bowl; indications of eyes, mouths,
nose, and moustache cluster in the
center and upper right; and tene-
brous chiaroscuro molds the faceted
planes throughout. This masterful
drawing, a large-scale study for a
section of* Man with a Violin *(in the
Philadelphia Museum's Arensberg
collection), was first exhibited at
Alfred Flechtheim's innovative Ber-
lin gallery.*

*Prints and Drawings: A Guide to a Better Understanding of Modern Draughts-
manship* (1954), a popular book with an introduction by Alfred Barr. The
warm relationship between Sachs and Barr was again demonstrated in 1941,
when Sachs managed to get Picasso's *Guernica* sent up from the Modern for
installation in Warburg Hall at the Fogg (Fig. 36). The seminal painting was
installed on two separate occasions, the first from September 29 to October
20, 1941, and again in 1942 from June to September. Presented as a token of
solidarity with Picasso in his outrage over the Fascist bombing of the small
Basque village, the installation was a cultural event. The painting's radically
reduced coloration, massive size, and formal inventiveness prompted newspa-
per headlines such as "FANTASMAGORIA OR PLAIN 'NUTS': HARVARD DIVISION
OVER PICASSO." Professor Benjamin Rowland's press release attempted to

40. EDGAR DEGAS
(1843–1917) French
Portrait of Madame Olivier Villette
*(1872). Oil on canvas. 46.4 x 32.7 cm.
(18¼ x 12⅞ in.). 1925.7. Gift,
C. Chauncey Stillman.*

*Painted in Degas's studio on the rue
Blanche, this quickly executed por-
trait exemplifies the brilliant formal
inventiveness of the artist's mature
style. After meeting Manet, Berthe
Morisot, and the younger Impres-
sionist painters who fomented their
artistic revolution at the Café Guer-
bois in Paris, Degas had abandoned
the classical compositions and his-
tory paintings of his early years. He
never lost his respect for earlier tra-
ditions, however, nor his preference
for indoor scenes, where light pro-
vides mood and drama as much as
illumination. In Madame Villette's
portrait, he challenged himself by
silhouetting the subject against a
bright window. Her red garment
serves to define the form of her
seated figure, setting off her face,
which is painted in summary, al-
most schematic form. In the window
itself, Degas indulged his most dis-
junctive sensibilities. Each pane
presents an entirely different picture,
the overall effect of which cannot be
precisely unified to reconstruct a
consistent reality outside.*

39. PAUL CÉZANNE
(1839–1906) French
Auvers, Small Houses *(1874-75). Oil
on canvas. 40.6 x 53.3 cm.
(16 x 21 in.). 1934.28. Bequest,
Mrs. Annie Swan Coburn.*

*Cézanne, who described himself in a
1906 exhibition catalogue as a pupil
of Camille Pissarro, shared with
that Impressionist an interest in the
village of Auvers. In its mastery of
composition,* Auvers, Small Houses
*already employs "passage,"
Cézanne's famous technique in
which the planes of selected forms
are brushed into one another, unify-
ing foreground and background
and creating a shallow pictorial
space. More fully expressed in
Cézanne's mature works, "passage"
provided the Cubists with a method
of constructing tightly interlocking
faceted planes whose flickering
light would illuminate form in a
new way.*

41. EDGAR DEGAS
(1843–1917) French
The Cotton Merchants (1873). Oil
on canvas. 58.4 x 71.1 cm. (23 x
28 in.). 1929.90. Gift, Herbert N.
Strauss.

Once thought to be a study for the
large painting of the New Orleans
cotton exchange now in the Munici-
pal Museum in Pau, southwestern
France, The Cotton Merchants was
actually painted later than the Pau
canvas. It is freer and less finished
than the earlier work, and Degas

must have been describing it when
he wrote to his friend the painter
James Tissot: "I am preparing an-
other, less complicated, better art,
where the people are in summer
dress, white walls, a sea of cotton on
the tables." Although intoxicated by
his visit to New Orleans (where his
mother had been born and two of his
brothers were established cotton
merchants), Degas found it impossi-
ble to paint productively amid such
stimulation: "I am hoarding projects
which would require ten lives to put
into execution. I shall abandon

them in six weeks, without regret, to
return to and to leave no more MY
HOME." This would seem to explain
the sketchlike quality of the paint-
ing, which portrays Degas's mater-
nal uncle, Michel Musson (in top
hat), in his New Orleans office. The
play of whites, creams, and beiges
achieves Degas's aim of a "less com-
plicated" art. He turned away from
the implications of this freer style
when he returned to Paris, produc-
ing highly structured compositions
of the dance.

42. VINCENT VAN GOGH
(1853–1890) Dutch
Peasant of the Camargue, 1888. Pen
and brown ink over graphite on
paper. 49.4 x 38 cm. (19½ x 14⅞
in.). 1943.515. Bequest, Grenville L.
Winthrop.

*The sureness of line and exquisite
detail of this work mark it as one of
van Gogh's greatest portrait draw-
ings. Its masterful control and un-
usually large scale indicate that the
artist intended* Peasant of the Ca-
margue, *a portrait of Patience Esca-
lier, as a finished work rather than a
study. Fascinated by the peasant's
gnarled features, van Gogh also
painted him in the 1888* Portrait of
Patience Escalier *(private collec-
tion). Van Gogh portrayed the fur-
rows in Escalier's face as he did the
rocks in his landscapes, conveying a
sense of timelessness and endurance.*

43. CAMILLE PISSARRO
(1830–1903) French
Banks of the Oise, 1874. Oil on
canvas on panel. 45.7 x 38.1 cm.
(18 x 15 in.). 1942.204. Gift,
Grenville L. Winthrop.

In 1874, the year Banks of the Oise
*was completed, Pissarro exhibited
ten works in the first group exhibi-
tion of the Impressionists. While
Pissarro had strong political con-
victions—he was a socialist with
anarchist ideas—he was finally a
gentle, calm man and a great
teacher. The delicate intimacy of the
scene in* Banks of the Oise *reveals
the gentle nature of his personality,
which drew even the most irascible of
his colleagues, Cézanne and Degas,
into friendship with him.*

explain what many saw as the painting's more outrageous aspects. Believing
that its formal innovations were due solely to its psychological goals, Rowland
inadvertently echoed the early debate about Cubism's "psychotic" tendencies:
"It may at first strike you as completely crazy because we are not accustomed
to, and do not fully understand art venturing into the realm of the psychologi-
cal and the super-real world of the mind." However it was presented to the
press and students, Sachs was thrilled to have the great painting in Cam-
bridge, as he indicated in his telegram to Barr: "A THOUSAND THANKS . . . THIS
WILL START ROWLAND'S NEW COURSE WITH A BANG AS YOU SAY."[19]

Sachs's enthusiasm and energy instantly communicated itself to the many
private collectors he cultivated for the Fogg—often as the result of a single
visit. A ceaseless traveler, Sachs visited the Chicago collector Annie Swan
Coburn early in his Fogg career. His admiration for her collection prompted
the gift in 1934 of ten works by Degas, Forain, Renoir, van Gogh, Toulouse-
Lautrec, Manet, Monet, and Cézanne. Among these were Cézanne's important
Auvers, Small Houses (Fig. 39) and Manet's *Study of a Blond Man* (Fig. 37). Her
gift of funds allowed John Coolidge to acquire in 1952 Picasso's *Man with a
Pipe* (Fig. 38). Similarly, a single trip to the New York galleries with railroad
tycoon Chauncey Stillman—who had never before collected art—prompted
the gift of Degas's luminous *Portrait of Mme. Olivier Villette,* (Fig. 40). While
lecturing in Montpelier, home of the early Impressionist Frédéric Bazille,
Sachs paid a visit to Bazille's family, the de Salinelles. Expressing his delight at
the large *Summer Scene* (Fig. 15) and his deep admiration for the work of the
then little-known artist (who had died, at age thirty, on the battlefield during

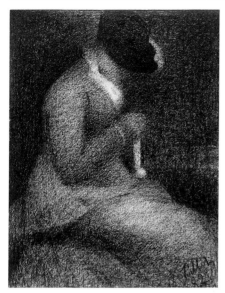

44. GEORGES SEURAT
(1859–1891) French
Woman Knitting, *1882. Black crayon with metallic silver paint and black chalk on paper. 32.2 x 24.5 cm. (12¾ x 9¾ in.). 1943.919. Bequest, Grenville L. Winthrop.*

Although Seurat studied scientific treatises on color and developed complex color theories of his own, from 1881 to 1882 he devoted himself primarily to drawing. This exquisite conté crayon drawing, intended as a finished work rather than a study, continues Seurat's interest in creating solid, stable forms through a highly textural technique. To model the figure, the artist relied on the range of tones and values the crayon could produce, rather than on line. This relates to his painting technique, through which he created form with thousands of closely positioned strokes of pure primary colors.

45. PAUL MANSHIP
(1885–1966) American
Sarah Janet Manship, *1930. Marble. 49.5 x 21.6 cm. (19½ x 8½ in.). 1943.1035. Bequest, Grenville L. Winthrop.*

Early in the century, Paul Manship had been a force for change in American sculpture. Apprenticed to the traditional, albeit utterly American, sculptor John Gutzon Borglum, who carved the presidential monument at Mount Rushmore, Manship turned away from the standard models of classical antiquity and toward the "primitive" styles of archaic Greek and Egyptian sculpture and, later, Oriental and Romanesque art. Although Manship's style was no longer in the vanguard when he carved this portrait sculpture of his fourth child, his contributions to the more modern work of Gaston Lachaise (who worked with him for a time) and Elie Nadelman can be seen in the smoothly finished, almost mannerist hardness of the surface, the elegant patterns of the drapery folds (modeled after the tunics, or chitons, of archaic Greek kouroi sculptures), and the closely observed yet stylized features of this intense, seraphic portrait. The sculpture was acquired by Grenville Winthrop at the suggestion of his agent, Martin Birnbaum, who was helping Manship to mount his 1935 retrospective at the Tate Gallery at the time.

the Franco-Prussian war), he was even more delighted when the family conveyed the painting as a gift four years later. At that time—1937—it was the only signed and dated Bazille in America, and it remains one of the finest examples of early Impressionism.

But the richest gifts of modern art came after Sachs's more prolonged contacts with a few donors. The bequests of Grenville L. Winthrop and Maurice Wertheim, two very different New Yorkers and Harvard men, re-

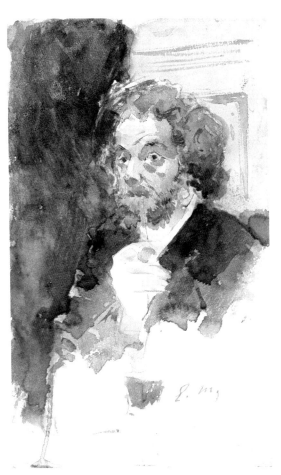

46. JAMES A. M. WHISTLER
(1834–1903) American
Nocturne in Blue and Silver,
*1871–72. Oil on canvas. 44.5 x 60.3
cm. (17½ x 23¾ in.). 1943.176.
Bequest, Grenville L. Winthrop.*

Whistler became a celebrated champion of art for art's sake in 1878, when he sued John Ruskin for libel after the art critic had scorned Whistler's apparently casual, indiscriminate application of paint. When Nocturne, one of a series of paintings of London at night, was presented in the trial as evidence of Whistler's approach to painting, the New York Semi-Weekly Tribune, covering the trial, reported the "scandalous" fact that the artist "began and completed [Nocturne] in a day, after having arranged the thing in his mind." Today, the poetic perfection of the work seems unquestionable, its harmony reinforced by the title, which relates the painting to music and emphasizes its haunting mood.

47. EDOUARD MANET
(1832–1883) French
Portrait of Gilbert-Marcellin
Desboutin *(c. 1875). Watercolor over graphite on paper. 22.9 x 14 cm. (9 x 5½ in.). 1943.386. Bequest, Grenville L. Winthrop.*

In 1930 Grenville Winthrop's agent, Martin Birnbaum, sent him a cable urging the purchase of this watercolor portrait. After several days of negotiation, Birnbaum secured the work for Winthrop, outmaneuvering an agent for a prestigious New York gallery. This watercolor portrait of an artist friend was done around the same time as Manet's most impressionistically rendered and brightly colored oils.

48. EDGAR DEGAS

(1843–1917) French
Petite danseuse de quatorze ans
(Little Dancer, Fourteen Years Old)
(1880; cast c. 1922). Bronze, with
cloth and ribbon. 99.1 x 40 x 35.6
cm. (39 x 15¾ x 14 in.). 1943.1128.
Bequest, Grenville L. Winthrop.

The wax model for Little Dancer *is
Degas's first known attempt at mod-
eling the human form, and the only
statuette he ever exhibited. After re-
turning from New Orleans in 1873,
Degas devoted himself to the study of
the "little rats" of the ballet—the
painfully thin, lower-class girls who
were just beginning their long, ardu-
ous journey toward becoming baller-
inas. The formal innovations of the
original wax model, with its wax-
covered cloth bodice and shoes and
its soft gauze tutu, drew almost more
reaction than the work itself. Viewers
imagined that they saw real hair on
the creature, or ribbons on her belt
and temples. Paul Mantz wrote in*
Le Temps *(April 1881), "Mr. Degas
dreamed of an ideal of ugliness. The
happy man! He has achieved it."
The work was cast posthumously by
master craftsman A. A. Hebrard in
1922, but even in its more restrained
cast version, where the bodice and
shoes are bronze, the work asserts it-
self as unique in Degas's oeuvre and
in the history of modern sculpture.*

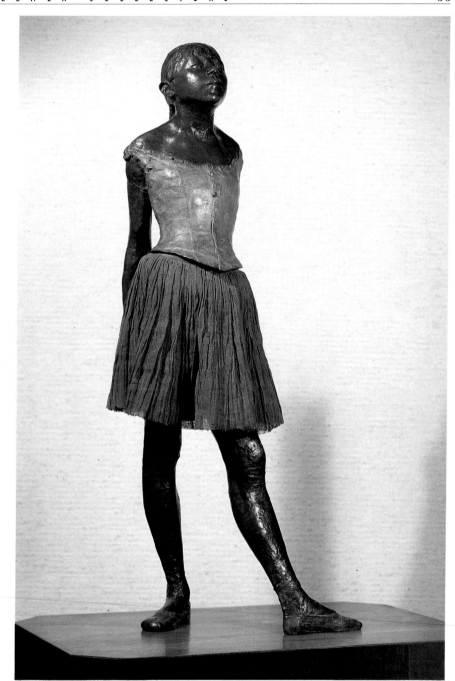

sulted from a long relationship with the university and its art museums. A man of highly cultivated tastes, Winthrop had taken Norton's classes in the late 1890s and remembered them "with keen delight."[20] He began collecting art early, but with the death of his wife in 1900, it became a passion. Despite the ambition of his brilliant agent, Martin Birnbaum, who wanted the collection enshrined in a museum of its own, Winthrop had determined as early as 1919 that it would go to the Fogg. Like Sachs and Forbes, Winthrop bought carefully and comprehensively, always thinking of the Harvard museums. Sachs, mindful of Winthrop's intentions, brought his Fogg museum course students each year to Winthrop's New York apartment, where they would be quizzed by their host about his latest acquisition.

Winthrop's ultimate requirement for his remarkably catholic collection was that the works "must possess music."[21] Norton's definition of poetry is echoed here, in the metonymy of music with the visual arts, but Winthrop extended it into realms that Norton would have paled to see. While he would have endorsed Winthrop's purchases of the Pre-Raphaelites (which comprise one of the finest such collections in the world), he would have questioned his taste for James McNeill Whistler, whom Ruskin had accused of "flinging a pot of paint" in the face of the public, a slur that instigated Whistler's famous libel suit. Winthrop's choice of Whistler's exquisite *Nocturne in Blue and Silver* (Fig. 46) might have posed particular difficulty for Norton, since it had been brought to the libel trial as evidence and treated by the press as scandalously unfinished. Norton would also have objected to such paintings as the loose Manet *Portrait of Gilbert-Marcellin Desboutin* (Fig. 47), the shocking "dressed" Degas sculpture *Little Dancer, Fourteen Years Old* (Fig. 48), the extraordinarily odd Paul Manship marble *Sarah Janet Manship* (Fig. 45), and other works in Winthrop's collection. It is a tribute to Winthrop's (as well as Birnbaum's) astonishing eye that such a range of styles and media can be incorporated in this book and exhibition, without even touching the remainder of his 3,500 brilliant acquisitions of Chinese and Egyptian objects, European sculpture, and early nineteenth-century French painting. In more than one area, the Winthrop material ranks with the finest in the world.

Having retired from law and business after only seven years, refusing to travel abroad, dressing always in black, excluding flowers from his Lenox, Massachusetts, garden, and cultivating flocks of Chinese pheasants, Winthrop would have seemed a rarefied aesthete to the worldly and dynamic

Maurice Wertheim. Wertheim graduated only seventeen years after Winthrop, but could not have inhabited a more different world. Banker, theatrical producer, owner of the *Nation*, competitive chess player, and world traveler, Wertheim was the quintessential enlightened "man of affairs" whom Sachs saw as the hope of the nation. Friends from New York days, Sachs and Wertheim corresponded often about the collection and its ultimate donation to Harvard. As Wertheim drew up his will in the 1940s, he apparently gave some thought to establishing a separate museum on campus, but after his death it was agreed that the bequest should be installed as a permanent collection in the Fogg Museum.[22]

The Winthrop and Wertheim bequests, along with that of Sachs himself, signaled the end of an era. After Forbes and Sachs there would be many acquisitions in the modern field, but it could no longer be taken for granted that Harvard graduates would collect with only the Fogg in mind. The phenomenal increase in the market value of art and the proliferation of fiercely competitive museums made major gifts of artworks increasingly less likely. As America secured its position of economic and cultural dominance after World War II, a new and aggressive program of acquisitions was needed to maintain the vitality of the art museums. John Coolidge made it his priority to create one.

49. CONSTANTIN BRANCUSI
(1876–1957) Rumanian
Caryatid II *(1915). Red oak. 166.6 x
43.2 cm. (65⅝ x 17 in.). 1968.2.
Partial gift of William A. Coolidge,
Hazen Foundation, and Max
Wasserman; and partial purchase,
Francis H. Burr and Alpheus Hyatt
Funds.*

Related to the more rounded Carya-
tid *in the Centre Georges Pompidou
(Musée National d'Art Moderne,
Paris), the Fogg's work shows Bran-
cusi's pioneering interest in African
sculpture, direct carving, and pri-
mary forms. Like many of his con-
temporaries, Brancusi often dis-
dained the use of "fine" materials
such as marble and bronze. Here he
chose a rough, split, and partially
rotted piece of red oak, perhaps in-
trigued by its evocation of ancient
African ritual pieces. Early photo-
graphs show that Brancusi used*
Caryatid II *as a base for one of his
small wooden sculptures,* Child's
Head, *from the early 1920s (later re-
worked). It is also known from early
catalogues and photographs that
the Fogg's sculpture was originally
twenty-one inches taller when it was
in the collection of John Quinn. It
was cut down, probably by the artist,
around 1926, when Brancusi had
begun to repudiate his prior involve-
ment with African sculpture. Yet the
frontal symmetry and bellying
curve of* Caryatid II, *the directness of
its technique, and its ribbed back
and upper torso still attest to African
models, brilliantly transformed in
this modern image of the ancient
caryatid—the human form as ar-
chitectural member.*

3 The Acquisitive Years, 1948–1968: *An Informal Memoir by John Coolidge*

WHEN Edward Forbes and Paul Sachs were awarded honorary degrees on the eve of their retirement in 1944, President James B. Conant described them as "mendicants of genius." They were also planners of vision and during the thirties had assembled for their successors at the Fogg what seemed like an ample endowment. With World War II and the inflation that followed it, their hard-won endowment was rendered inadequate by at least a million dollars. The Fogg was unable to meet its $200,000 budget, even though wages and salaries had been frozen far below the going rate. For many years after the war it was touch and go, as a new and inexperienced museum administration cut costs with miserly ruthlessness. The *Fogg Museum Bulletin* was abandoned, and research in conservation was greatly reduced. The struggle was first to raise enough funds to support a reduced performance, and then to pay off the accumulated debt (with interest!) to the university. It would be more than fifteen arduous years before the Fogg was paying proper salaries and running fully in the black. It is therefore needless to say that, when I became director of the Fogg in 1948, the serious purchase of works of art was hardly possible. There was an income of only $7,000 restricted for this purpose, and obviously nothing more could be taken out of general funds. Likewise, there was very little money available to mount exhibitions of contemporary art, unless they could be funded by a special donation.

But these problems were as nothing in light of the legacy left by Forbes and Sachs, especially the human legacy. The four curators, Langdon Warner, Jakob Rosenberg, Charles Kuhn, and Agnes Mongan, had become expert in the discovery of improbable bargains, and Professor Frederick Deknatel offered the guidance of his superb taste and judgment. Moreover, that extraordinary group of collectors, whose fondness for the institution had been so effectively developed by Sachs and Forbes over the years, remained loyal to the Fogg. Particularly notable in this group were the Wertheims, Mrs. Lois Orswell, Mr. and Mrs. Joseph Pulitzer, Jr., Ralph Colin, Joseph Hazen, G. David Thompson, and Jeanne and Max Wasserman. Indeed, their affection

50. *Edward Forbes (left) and John Coolidge in the Fogg galleries, April 1960.*

51. LYONEL FEININGER
(1871–1956) American
Bird Cloud, *1926. Oil on canvas.*
43.8 x 71.1 cm. (17¼ x 28 in.).
BR1950.414. Purchase in memory of
Eda K. Loeb.

*The Busch-Reisinger Museum has
an extensive Feininger archive con-
taining, among other things, two
watercolors and a number of prepar-
atory studies for* Bird Cloud. *Fein-
inger's obsession with the study of
nature allowed him to metamor-
phose natural forms through succes-
sive drawings, from cloud, to bird,
to an abstracted birdlike shape
formed by delicate opaque and
transparent overlapping planes. Iri-
descent shafts of light evoke a heav-
enly majesty, and the tiny figure at
the left reminds the viewer of the
dwarfed inconsequence of human
beings in relation to nature. Fein-
inger painted this work while a mas-
ter at the Bauhaus, during the same
year in which he became a member
of the* Blaue Reiter *group with Klee
and Kandinsky.*

proved contagious, so that then, as now, we could hope that timely gifts, contributions for special purposes, or bequests would ultimately give the museum works of art of a quality it could not possibly afford under normal circumstances. Almost half of the work presented in this book consists of objects that arrived at the Fogg during the twenty years of my tenure as director. This memoir is intended to recall the policies we followed, the good luck that befell us, and the errors we made—on the assumption that all of this, in part, accounts for the presence of some objects and the absence of others at least equally worthy.

It was not obvious in 1948 that acquisitions of twentieth-century art would ever become a significant part of the Fogg's collections. In this book, we have seen something of the stately "fine arts" tradition that governed the Fogg and informed its early collections. But true to Harvard's policy of noninterference with departmental affairs, the university in no way obligated the museum's postwar administration to continue in that tradition. The position that twentieth-century art would occupy in the Fogg's activities was left entirely up to the staff and to the concerned professors in the fine arts department. It seemed obvious to the younger members of both groups that the Fogg, as Harvard's principal art museum, should concern itself with the best art of the twentieth century, just as other branches of the university were concerned with the best contemporary achievements in their own fields. There was one important limitation to our efforts. Few are aware that Harvard was one of three institutions that participated in the creation of the Museum of Fine Arts in Boston (the others were the Boston Athenaeum and MIT). For many years, the university had been responsible for appointing three members of the Boston Museum's trustees. It was established policy, therefore, that the Fogg

52. PABLO PICASSO
(1881–1973) Spanish
Glass of Absinthe and Cigarette
(1914). Oil on wooden panel
mounted on cardboard. 16 x 11.6 cm.
(6⅝ x 4⁹/₁₆ in.). 1975.3. Anonymous
Gift.

Despite its small scale, Glass of Absinthe and Cigarette *provides a perfect summary of the new qualities offered by synthetic Cubism, to which Picasso and Braque both turned after achieving an almost hermetic refinement in their analytical Cubist technique. The reintroduction of pattern and color enhanced their available tools, also reconfirming the role of the contour line and inviting sheer visual pleasure. Many of the forms from earlier Cubism are maintained, such as the nearly circular opening for the glass (where perspective would render an ellipse) and the multiple views of the glass itself (which is bulbous on the left, angular in the center, and classically curved on the right). The motif of the absinthe glass and its cube of sugar were also pursued in an edition of bronze sculptures Picasso produced in the same year.*

and Busch-Reisinger would not compete with Boston for the support of donors or collectors, although the university never turned away those who offered help of their own free will.

Although we could not muster the kind of power represented by a major museum's board, we had other advantages denied to a larger museum. Unlike a public museum, for example, we are governed not by a board of trustees, but by the university's rather distant Board of Overseers. The Overseers, in turn, appoint (with our suggestions) a Visiting Committee, comprising art historians, museum professionals, private collectors, and other representatives from the field. This is not the place to discuss the immense improvements that the Fogg has achieved as a result of its Visiting Committee's reports to the Overseers on such subjects as the rewording of a bequest or the completion of a building project, but it is the place to record the benefit received from its members as a direct result of their visits.

The meetings of the Visiting Committee bring members in touch with every activity of the museum and the department, at every level of staff, faculty, and students, providing the committee with a far deeper understanding of the workings of the institution than that available to a normal board of trustees. As

53. HENRI MATISSE
(1869–1954) French
Jazz, Le Lanceur de Couteaux
(Knife Thrower) *(1947). Pochoir
(color stencil). Entire sheet: 42.2 x
64.7 cm. (16⅝ x 25½ in.). M12, 171.
Purchase, Francis Burr Fund.*

a result, the committee members gain an excellent grasp of how intimately the museum's diverse activities are related and a sense of how closely they are motivated by the needs of instruction. The members are vividly aware of what works of art we need, and how variously and effectively we use them. It is to this awareness, more than anything else, that we owe the growth of our collections. This is particularly true of twentieth-century art, since no other objects arouse such passion among so many students as the art of their own age. I counted on this passion as I approached the job of director in 1948.

Under the administration of Edward Forbes and Paul Sachs the Fogg's collections of nineteenth- and twentieth-century art had grown strong, with the potential of gifts to make them yet stronger. Jakob Rosenberg's enthusiasm and acumen had resulted in a sizeable collection of Picasso prints, and Charles Kuhn was continuing to build an outstanding collection of twentieth-century German art at the Busch-Reisinger. The interest and commitment of our professors, particularly Benjamin Rowland and Frederick Deknatel, further fired the enthusiasm of our students, who were always eager to learn more about current activity. But the Fogg still looked to Europe for greatness in art, and there was hardly a nonfigurative work in Harvard's entire collection.

54. HENRI MATISSE

Jazz, Frontispiece *(1947). Pochoir (color stencil). Entire sheet: 42.2 x 64.7 cm. (16⅝ x 25½ in.). M12, 157. Purchase, Francis Burr Fund.*

Jazz was Matisse's first extended foray into the cut-and-pasted colored paper technique. Printing from the original cutouts was a labor of love: the same paints were used, and the gradations in density were maintained by painting through stencils. The unusual use of the artist's handwriting for the text may have originated in the scarcity of complete type fonts after the war.

The artist's text comprises his own richly individual reflections on God, the airplane (this next to Icarus), the cowboy, the lagoon, the circus, the theater, and his equally idiosyncratic iconography. The image shows black Icarus, his red heart glowing, who floats rather than plummets through the starry heavens. The Knife Thrower aims his masculine barbs at the heart of the curvilinear female form on the facing page. Jazz enchants us with its rich, hot colors and its mysterious narrative. It stands as one of the monuments to Matisse's genius as a colorist and "decorateur."

55. HENRI MATISSE

Jazz, Icarus *(1947). Pochoir (color stencil). Entire sheet: 42.2 x 64.7 cm. (16⅝ x 25½ in.). M12, 164. Purchase, Francis Burr Fund.*

56. FERNAND LÉGER
(1881–1955) French
Les Plongeurs (The Divers), *1943.*
Oil on canvas. 88.9 x 106.7 cm. (35
x 42 in.). 1964.60. Gift, Mr. and Mrs.
Josep Lluis Sert.

Before leaving Marseilles for a six-
year sojourn in America, Léger had
started a series of paintings that
grew out of his observations of
crowds at the beach. He continued
these new works in America, where
this canvas was painted. Planes of
color float beneath the transparent
divers, who have the aspect of benev-
olent jellyfish in their directionless
buoyancy. Dedicated to the Spanish
architect Josep Lluis Sert, the Fogg's
canvas is a later version of a larger
canvas in a New York private
collection.

Everybody assumed that Charles Kuhn's activities would continue, as indeed they did and with consistently splendid results. But what of the Fogg? I consulted Alfred Barr, long-time friend of the museum and chairman of the Visiting Committee for many years. "You need more works by the four great painters of this century: Matisse, Picasso, Braque, and Klee," he declared, to which I added, "as well as sculpture by Brancusi." None of us was particularly attracted to the Surrealists, and, despite Joe Pulitzer's early prompting, we paid little attention to contemporary American art for far too many years.

Characteristically, perhaps, it was the most conservative of our predecessors who launched us on our way. Although my appointment did not take effect until July 1, 1948, it had been announced five or six months before, and I was already thinking of potential new directions. Earlier in the year, I had visited a splendid Matisse exhibition at the Philadelphia Museum of Art, and on my return spoke of it enthusiastically to Arthur Pope, then director of the Fogg. I told Pope that I had been especially impressed by *Jazz*. A week later he informed me that he had purchased that unrivaled volume of contemporary prints for the Fogg (Figs. 53–55). Conservative, but with the sensitivity of a painter and scholar of painting, Pope was especially sympathetic to Matisse's brilliant sense of color. The episode was symbolic of my experience with the older generation at the Fogg: if they had little active interest in modern art, neither did they actively oppose it nor, generally, did they fail to "see something in it."

57. PAUL KLEE
(1879–1940) Swiss
Heisse Jagd (Hot Pursuit) *(1939).*
Colored paste and oil on paper on
jute. 48.3 x 64.8 cm. (19 x 25½ in.).
1955.66. Gift, Mr. and Mrs. Alfred
Jaretzki, Jr.

*Although he exhibited briefly with
the* Blaue Reiter *school in Munich
and taught at the Bauhaus for eight
years, Paul Klee was really a school
unto himself. He is celebrated for his
ability to conceptualize and render
the range of human activity in bril-
liantly reduced and often humorous
terms. Using a whimsical hiero-
glyphic vocabulary,* Heisse Jagd *de-
picts a man targeting his female
prey—evocative of much neo-Ex-
pressionist work in its primitivizing
aspect and its graphic reductivism.*

We proceeded to follow Alfred Barr's other suggestions, with the exception of Klee. But this was only an apparent exception. Modest as the Fogg's funds were, those of the Busch-Reisinger were even more limited. Hence, if an important work of German art appeared on the market (remember that, until recently, German art of all periods was relatively cheap), the Fogg might purchase it. Then, as the Busch-Reisinger's funds accumulated, Charles Kuhn would buy the piece from the Fogg at the original price. Thus the Fogg did buy works by Klee, but sold them later to the Busch-Reisinger. Similarly, we would make a joint purchase if an unusual opportunity arose, as in the case of the incomparable Lyonel Feininger, *Bird-Cloud* (Fig. 51); or we would place a work on long-term loan from the Fogg to the Busch, such as Mr. and Mrs. Alfred Jaretzki's beautiful Klee, *Heisse Jagd (Hot Pursuit)* (Fig. 57).

In addition to Charles Kuhn and Frederick Deknatel, both of whom had assembled distinguished private collections of modern art, others in Cambridge were supportive of contemporary art. For example, Eric Schroeder, honorary curator of Islamic Art, was the most deeply generous of men. He had as remarkable an eye as anyone I have ever known, as well as the best capacity to explain, justify, and poeticize the visual qualities of art. Many years previously he had acquired a Cubist Picasso of 1911 for his own collection. Some years after his untimely death, this magnificent painting, *La Grenade*, was given to the Fogg in his honor (Fig. 58).

After a brilliant career in Europe at that nexus of modernism, the Bauhaus,

58. PABLO PICASSO
(1881–1973) Spanish
La Grenade (Pomegranate, Glass,
and Pipe) *(1911). Oil on canvas. 21.6
x 34.6 cm. (8½ x 13⅝ in.). 1972.12.
Anonymous Gift in memory of Eric
Schroeder.*

In the high analytic Cubism of La
Grenade, *Picasso has all but aban-
doned illusionistic form in favor of
an elaborate system of signs that in-
dicate, rather than render, the
painting's subjects. The pomegran-
ate is signified by its seeds, which lie
clustered to the right of center; the
glass is indicated by various arcs
and sections of ellipses; the pipe by a
set of schema such as concentric cir-
cles for its bowl. A portion of the
word* café *at upper right plays the
role Braque and Picasso had earlier
invented. It anchors the surface of
the picture plane and flattens the
spatial illusion, serving incidently
as both an abstract form and a ver-
bal clue to the subject's locale.*

Walter Gropius came to Harvard in 1937 as head of architecture at the
Graduate School of Design (a new entity formed in 1936 from the schools of
architecture, landscape architecture, and city planning). He was enormously
supportive of contemporary art. In 1950 he commissioned works of art from
Miró, Albers, Arp, and other distinguished artists for his Harkness Commons
building, which he had designed to be Harvard's first structure in the Interna-
tional Style.

Professor Reginald Isaacs, also of the Graduate School of Design, made
important contributions. He spent occasional summers in the Hamptons on
Long Island, and mentioned to a friend at a cocktail party that he loved
oysters. The friend said, "there's a man down the beach who knows a lot about
oysters." Reg looked him up, and he turned out to be Jackson Pollock. They
became friends, and Isaacs acquired several of his canvases, which were
repeatedly put on loan at the Fogg. It was through Reg's generosity that we
were able to acquire Pollock's *No. 2, 1950* (Frontispiece), surely the finest
Pollock in a university museum.

The present selection can only hint at the exceptional richness in the
collection of works by Joan Miró (Figs. 61, 67). Almost all of these are gifts
from another member of the Harvard community, Josep Lluis Sert, friend of
Miró and, like him, a Catalan. Sert designed a house for Miró, who paid him
with a painting; in this way his collection grew. Initially, I looked Sert up
because of my interest in urban development and the history of cities; soon, he
and his wife began to put their collection on loan here. When Josep Lluis died
in 1983, the Fogg gained a remarkable group of Miró paintings as well as
works by Fernand Léger (Fig. 56).

It was an extraordinary group of graduate students, among them Michael Fried, Rosalind Krauss, and Charles W. Millard, who made us aware of the importance of the New York School. Mike provided far more than simple information. An active critic throughout his years at Harvard, he mounted the well-known exhibition "Three American Painters: Kenneth Noland, Jules Olitski, Frank Stella," which had an enormous impact on the contemporary field. This, and a handful of modest purchases, brought forth a splendid series of gifts, including two paintings by Noland (Figs. 71, 72) and, less immediately, our three Stella paintings (Figs. 70, 73, 74).

But the majority of works in this book and exhibition came not from our purchased acquisitions or the special gifts they helped to stimulate. Rather, it was the same group of loyal long-time friends of the Fogg and Busch-Reisinger who ultimately bequeathed to us some or all of their most treasured possessions. The number of these patrons has been as impressive as their loyalty. In the late fifties and sixties the Fogg was receiving bequests of at least one significant collection each year. The range of such gifts was amazing, from Mrs. Rockefeller's Persian miniatures to the Jesse Strauses' Italian primitives and Charles Dunlap's rococo drawings.

As noted elsewhere, the most remarkable of these bequests were those of Grenville Winthrop and Maurice Wertheim. The individual who most resembles these men in his devotion to the university and his uncompromising sense of quality is Joseph Pulitzer, Jr., by far the greatest benefactor of the Fogg's activities in twentieth-century art. His first initiative was a modest grant that made possible an exhibition of the work of living artists, accompanied by lectures from them. We enthusiastically borrowed a Jackson Pollock, which I promptly hung sideways. (Characteristically, it was Eric Schroeder, Islamic curator and collector of Picasso's Cubist works, who first spotted the mistake.)

Joe next established a fund for the purchase of contemporary art, which helped greatly in the acquisition of our Alexander Calder mobile (Fig. 65), our Jackson Pollock (Frontispiece), and other works. And over the years, the Pulitzers have given the museum superlative works of modern art (Figs. 7, 73, 75–81, 83).

The Pulitzers' own collection surpasses those of many museums in range and quality. Unlike many museums, the Pulitzers have had it fully catalogued in a series of volumes. We have helped to write and publish these over the years and will do so again as their collection continues to grow. Joe has served the university as an Overseer, and as chairman or vice chairman of the Visiting

59. FERNAND LÉGER
(1881–1955) French
Branch R *(c. 1951). Bronze. 55.2 x 50.8 cm. (21¾ x 20 in.). 1962.183. Gift, Mr. and Mrs. Joseph H. Hazen.*

Léger began to work with metal in 1951, possibly through his involvement in the installation of the stained-glass windows he had designed for a church in Audincourt, France, near the Swiss and German border. Some of this interest in sculpture found expression in ceramics, such as the polychrome Great Black and Red Branch *(1951), in the Art Institute of Chicago. Related clearly to imagery in his paintings of the 1940s, the strong, planar branching forms were revived in Léger's 1951 mural for the Milan Triennale and carried into his sculpture with* Branch R.

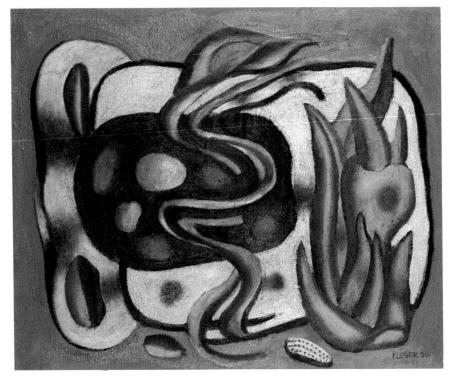

60. FERNAND LÉGER
(1881–1955) French
Composition, *1936. Oil on canvas.
36.8 x 44.8 cm. (14½ x 17⅝ in.).
1960.90. Gift, Mr. and Mrs. Harold
Gershinowitz.*

*In the mid 1930s, Léger turned from
the rounded, machine-tooled cylin-
ders of his early Cubism and the seg-
mented collagelike Cubism of the
1920s toward an exploration of more
organic forms. Influenced by Surre-
alism,* Composition *also partakes of
Léger's admiration for Henri Rous-
seau, whose hard, polished paint-
ings of tropical plants are echoed
here. The painting is closely related
to the Guggenheim Museum's* Com-
position with Aloes *(1935), which
exhibits the same interest in various
types of organic form.*

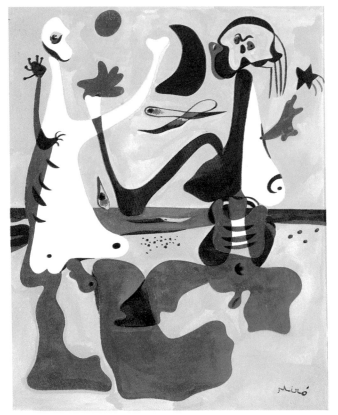

61. JOAN MIRÓ
(1893–1983) Spanish
Figures by the Sea, *1934. Gouache
on paper. 33 x 27.9 cm. (13 x 11 in.).
1964.58. Gift, Mr. and Mrs. Josep
Lluis Sert.*

*In this small gouache, Miró has
achieved remarkable intensity in his
Surrealist vocabulary. The frolick-
ing man and woman seem to have
the world in their grasp. The sense of
joy and lyricism that pervades the
work of this period represents Miró's
gift to Surrealism, a movement
often characterized by mysogyny
and despair. The delight in* Figures
by the Sea *was short-lived, however,
for Miró could not sustain such op-
timism confronted with the rise of
Fascism in his native Spain.*

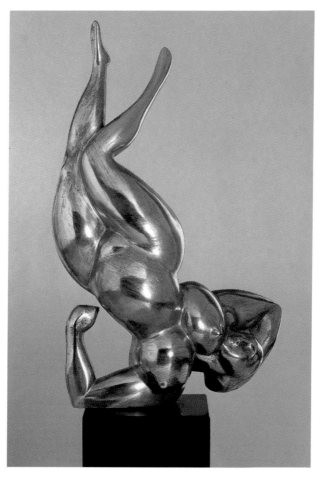

62. GASTON LACHAISE
(1882–1935) American
Acrobat, *1927. Bronze. 27 x 16.8 cm.
(10⅝ x 6⅝ in.). 1962.78. Bequest,
Marian H. Phinney.*

*Arriving from Paris at the turn of
the century, Gaston Lachaise felt
confident about the future of the vi-
sual arts in America. He exhibited in
the celebrated Armory Show of 1913
and participated fully in the emerg-
ing modern movement. Acrobat is a
late example of Lachaise's explora-
tion of the human form suspended
in space, an interest he pursued in
the similar ballooning volumes of
Floating Figure (1927), owned by
New York's Museum of Modern Art (a
proof cast of which is owned by the
Fogg). Despite its small size, Acrobat
suggests monumentality through its
rotund, distended forms.*

Committees to the Fogg and to the Department of Fine Arts. His most recent gesture was the extraordinary gift of a professorship in modern art. No other patron in the Fogg's history has contributed to the institution so faithfully and in such a variety of ways, each of them unique, imaginative, and helpful.

In my own collecting for the museums, my personal enthusiasm was the acquisition of sculpture, perhaps because of my architectural interests and perhaps because the field was open from both an academic and a curatorial perspective. Early on I began to acquire Baroque sculpture, particularly German Baroque, to fill gaps in the collections. Acquisitions of modern sculpture included Matisse's *Serf* and a modest Calder, *Little Blue Under Red* (Figs. 64, 65). The generosity of Jeanne and Max Wasserman and another collector made possible the acquisition of two Brancusis, among them the major wood sculpture *Caryatid II* (Fig. 49).

My strongest regret is not buying more of such sculpture. After the war it was relatively affordable, and it provided representation of major artists or periods that the Fogg might never otherwise have been able to acquire. For instance, a rare Géricault terra cotta was available once for the ridiculous sum of $900. It would have been an unusual find at any price, but some members

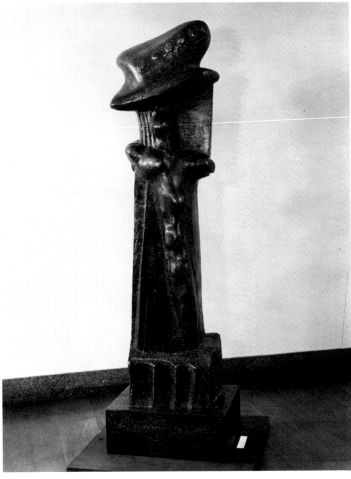

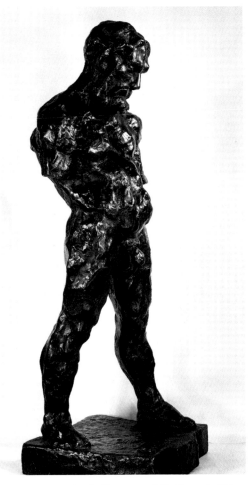

63. HENRY MOORE
(b. 1898) British
Upright Motive No. 8 *(c. 1954, cast
1955–56). Bronze. Height: 198.1 cm.
(78 in.). 1959.42. Gift, G. David
Thompson.*

*A study for a group of sculptures
(never completed) intended for the
courtyard of the Olivetti head-
quarters in Milan,* Upright Motive
No. 8 *is an unusual work in Moore's
oeuvre, which is known primarily
for horizontal forms with clear fig-
ural referents. The verticality grew
specifically out of Moore's plans for
the Olivetti site, which he felt called
for an upright rhythm, and the form
led in turn to his exploration of the
crucifixion theme. This theme was
not intended to be a public interpre-
tation, but it nonetheless illumi-
nates the crosslike figure that can be
seen under the large caplike form.*

64. HENRI MATISSE
(1869–1954) French
Serf *(1900–1903). Bronze.
92.7 x 32.4 cm. (36½ x 12¾ in.).
1953.42. Purchase, Alpheus Hyatt
Fund.*

The powerful striding form of
Serf *shows Matisse's debt to Rodin.
It is a kind of homage to the earlier
master's great* Saint John the Baptist
and, even more, to his armless The
Walking Man. *Matisse's feelings to-
ward Rodin were ambivalent, how-
ever; he had visited the aging sculp-
tor around 1900 with samples of his
work, and Rodin had allowed only
that the younger artist had a "facile
hand." It seems that Matisse never
visited Rodin again, and yet, for the
hundred or more sittings needed to
finish* Serf, *he sought out the
same model Rodin had used for*
Saint John *and* The Walking Man

*(an Italian named Bevilaqua). This
early work is especially important
because it shows the traditional roots
of Matisse's sculpture, which would
later become much more radically
abstract.*

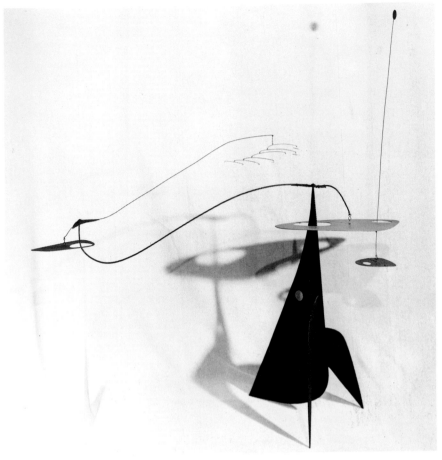

65. ALEXANDER CALDER
(1898–1976) American
Little Blue Under Red *(c. 1950).*
Painted metal. 147.3 x 208.3 cm.
(58 x 82 in.). 1955.99. Purchase,
Louise E. Bettens Fund.

*Alexander Calder, whose father and
grandfather were both well-known
sculptors, approached his work with
a concern for spatial organization
and mechanical forms that links
him to the Russian Constructivist
aesthetic of the early twentieth cen-
tury. Calder took one element the
Constructivists had explored and
made it the basis for his art, tracing
the movement of forms in space and
time. In addition, he enlivened his
abstract mobiles and stabiles with a
sense of humor, replacing figuration
with colorful, playful motion.*

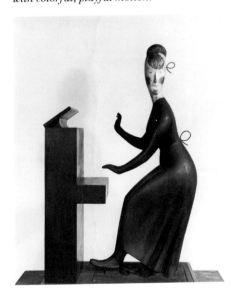

66. ELIE NADELMAN
(1882–1946) American
Pianiste *(c. 1917). Painted wood.
Height: 91.4 cm. (36 in.). 1956.200.
Gift, Dr. and Mrs. John P. Spiegel.*

*Born in Poland, Nadelman moved
as a young man first to Munich and
then to Paris, where he spent years
developing complex analytical ex-
periments on the nature of sculp-
tural form. In 1914, he produced
Vers l'unité plastique (Toward the
Unity of the Plastic Arts), a portfolio
of analytical drawings intended to
discover how volume could be de-
scribed, filled, and balanced. In his
time, he was considered the chief ex-
ponent of extreme modernism in
Paris, but Nadelman is rarely cred-
ited today for the influence he had
on Picasso, whose first Cubist sculp-
tures resemble the forms of the ex-
periments that Picasso had seen on
a visit to Nadelman's Paris studio*

*with Gertrude Stein. After Nadel-
man moved to New York in 1914, he
did a series of playful painted
wooden sculptures that included
Pianiste. The series, which evokes
the simplicity of folk art, was in-
spired by the artist's fascination with
the fickle types of high society. His
concurrent study of the silhouetted
forms in Georges Seurat's charcoal
sketches is also evident in Pianiste's
elegant, attenuated form.*

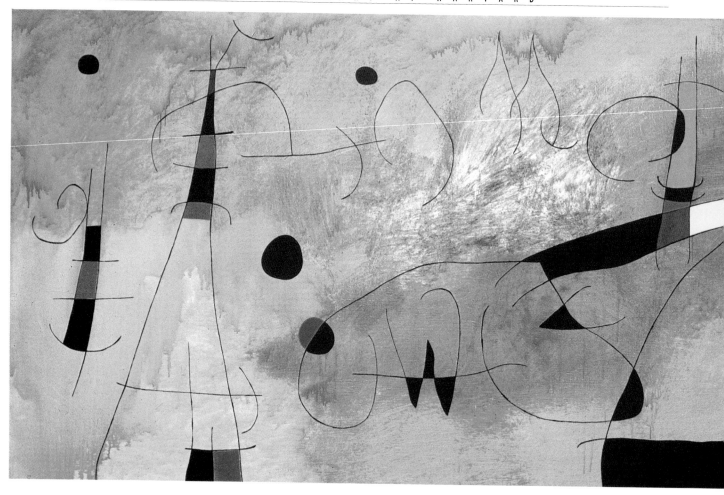

67. JOAN MIRÓ
(1893–1983) Spanish
Mural, March 20, 1961. *Oil on
canvas. 114.3 x 365.8 cm. (45 x 144
in.). 1964.54. Gift, Mr. and Mrs.
Josep Lluis Sert.*

*By the 1960s, Miró had largely
abandoned painting for the more
public enterprises of printing, sculp-
ture, and ceramic wall murals. The
painted* Mural *is thus a rare object,
whose existence (and donation) the
Fogg owes to the Spanish architect
Josep Lluis Sert. The deep friendship*

of the faculty thought it was so indecent that it would never be used for
teaching. Indecent it was, but it could still have been used for small seminars
and tutorials, especially today when standards in these matters have changed.

Similarly, we had a chance to buy Picasso's 1909 bronze, *Head of Fernande*,
for $2,500. I consulted Alfred Barr. He seemed dubious: "Is it documented?
What do you know about the cast?" At that time, we had neither the technical
facilities nor a sculpture curator to render an opinion, and we passed up the
opportunity. A chance came for another major piece when I visited a large
gallery where an exhibition of Matisse sculpture was soon to open. In the
vestibule was a large bronze of a seated nude. "How marvelous!" I thought.
But the proper thing to do was to wait until the show was open to see if the
piece was really suitable for our collection. It was, but meanwhile a private
collector had acquired it.

Despite these setbacks, the kind of modern art collection the museum
might ultimately hope to build became gradually clearer. With this clarifica-
tion came the realization that loans and exhibitions might generate acquisi-
tions on the one hand and temporarily bridge gaps in the collections on the

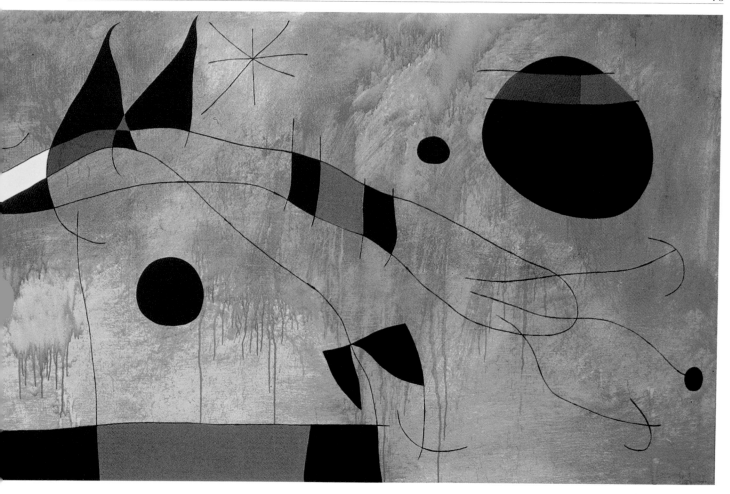

other. And as the Fogg's financial condition improved in the sixties, it became possible to think of a concerted policy of activities in modern art, all of which would lead ultimately to acquisitions.

A memorandum from my office to the staff suggested that "ultimately not less than one-quarter nor more than one-half of our independent activities [independent, that is, of the requirements of a specific art history course] be devoted to twentieth-century art." We aspired to significance, but in a field as volatile as contemporary art, we could not be restricted to the standards of quality held by any one group or individual. Accordingly, the most controversial exhibition that resulted from this policy was an installation of hitherto unexhibited works by Andrew Wyeth, whose able curators were Agnes Mongan and Philip Hofer. My position was summarized in the memorandum's conclusion:

The Fogg can probably never compete with larger and more specialized museums in the discovery of new talent. We will not be the first nor will our taste be the most unerring. Nonetheless we owe a duty to this community to pursue—without any pretensions—a program of high level critical presentation of the untried.[1]

between the two Catalans is attested by this painting, which Miró created for a wall of the Serts' house on Francis Avenue in Cambridge, Massachusetts. In Mural, *Miró returned to his style of the 1950s, in which his dreamlike "personages" progress across an atmospheric ground of modulated earth tones. It resembles the mural he painted for Gropius's Harkness Commons at Harvard, a painting that was later removed for reasons of conservation, and now resides at The Museum of Modern Art in New York.*

68. MORRIS LOUIS
(1912–1962) American
Blue Veil *(1958–59). Acrylic on*
canvas. 255.3 x 378.5 cm. (100½ x
149 in.). 1965.28. Gift, Lois Orswell
and Gifts for Special Uses Fund.

Born Morris Bernstein in Baltimore,
Maryland, Morris Louis took his fa-
ther's first name as a surname when
he set out to become a painter. His
earliest paintings were executed in a
Cubist, figurative style in the man-
ner of de Kooning, but, after he met
Helen Frankenthaler and Clement
Greenberg through his friendship
with Kenneth Noland, Louis's work
changed radically. First suggested to
Louis by Jackson Pollock's work, in
which pigment was soaked directly
into unprimed canvas, the stain
technique was demonstrated to him
with even greater force by Franken-
thaler's pioneering 1952 stain paint-
ing Mountains and Sea *(collection of*

the artist). Apart from a brief period
in 1954 when he made Abstract
Expressionist paintings (which he
subsequently destroyed), Louis con-
tinued to explore the formal possibil-
ities of the stain technique until his
untimely death from cancer in 1962.
Blue Veil *is an exceptional stain*
painting; its saturated color and
subtle harmonies, combined with its
unmanipulated, "effortless" surface,
exemplify the work of the color-field
painters. In Four-Three-Eight (Or-
ange Column; *fig. 69), Louis re-*
strained the lyricism of the veils to
produce a simple column of color.

4 Postwar Growth and New Directions:
The Discovery of Modern Art During the Coolidge Years

PAUL SACHS stated that the nineteenth century ended only after World War I, but it may be said with equal validity that the twentieth began only after World War II, at least with respect to America's acceptance of abstract art. Harvard had been slightly more advanced than much of America, but there was little in the collection to reflect this. It took the leadership of John Coolidge and the continued efforts of Charles Kuhn to make abstract modern art acceptable for the museums' collections.

Despite the high attendance at the 1913 Armory show in New York and its profound impact on a handful of New York artists, the achievement of Cubists and other modern artists had little national effect, and abstraction was an isolated and sporadic phenomenon in America during the thirties and forties. With the exception of the work of such pioneers as Arshile Gorky and Willem de Kooning, international movements languished in the shade of social realism, regionalism, and other retardataire trends. The war for acceptance of abstract modern art in America was won only after the peacetime consolidation of American power, when the country saw itself as the sole survivor and rightful heir of uprooted European culture. Abstraction could then be endorsed, because it could be identified with the liberal state, as "the visible evidence of the activity of free minds," and so distinguished from the totalitarian leftism of Stalinist Russia.[1]

Art historians acknowledged this political context for criticism and scholarship only in the most general way as abstract and modern art began to be shown around the country. Professor Rowland's press statement about *Guernica* had tied Picasso's formal innovations to his psychological, rather than political, aims. While viewers were encouraged to empathize with the painter's anguish over the bombing of the Basque village, the painting itself was to be viewed primarily as *art*, "venturing into the realm of the psychological and the super-real world of the mind."[2]

69. MORRIS LOUIS
(1912–1962) American
Four-Three-Eight (Orange Column)
(1960). Acrylic on canvas. 215.9 x
62.5 cm. (85 x 24⅝ in.). 1965.32.
Gift, Mrs. Abner Brenner.
See extended caption, page 74

Forbes and Sachs had similarly cherished the appeal of art to the emotions rather than its narrative content. But partly because of his continuing contact and close involvement with Alfred Barr, Sachs had also begun to emphasize what Bernard Berenson celebrated as "the infinitely painful learning of form as pure form."[3] After World War II, John Coolidge and his colleagues furthered this movement toward formalism (which would even become known as "the Fogg school"), but it was already in evidence by the late 1920s, and a broadside accompanying a 1931 exhibition titled "Modern Painting in Review," staged by the Harvard Society for Contemporary Art, explained:

A painting can never be the real object it seeks to imitate. Better than anything it can be a painting. It possesses its own resources for producing an equivalent to the real world.... The history of modern painting is a history of this shifting away from photographic vision toward internally organized expression.

Similarly, the brochure accompanying the "International Photography" exhibition of that same year proclaimed "the camera has a right to an individual medium of artistic expression, disassociated from the dependent categories of reproduction and slavish documentation."[4]

In architectural criticism, pioneered by Harvard graduate Henry-Russell Hitchcock, there was an even stronger tendency to denature the political aspects of the new modernist aesthetic in favor of its formal attributes. Helen Searing has observed acutely in "International Style: The Crimson Connection" that Hitchcock's and Philip Johnson's choice of the designation "International Style" had far-reaching and fateful results:

the joining of "international" with "style," whether fortuitous or a knowing ploy, would be crucial in effecting American acceptance of European Modernism. At the time, "international" immediately conjured up the organizations of the same name (the first two Internationals were socialist, the third, the Comintern of 1919, bolshevik) and the anti-nationalist, anti-imperialist stance of leftists throughout the world.... Coupling style with international, however, removed from the latter its Marxist implications and made the Modern movement no more threatening politically than the Renaissance or the Gothic. One could also read in the term the art historical notion that like all styles it would eventually run its course; one need not be eternally in thrall to the ineluctable *Zeitgeist*.

Searing hints at the role Sachs may have had in this formalist movement: "The Harvard preoccupation with formal issues bespeaks a sympathy for a French

70. FRANK STELLA
(b. 1936) American
Red River Valley *(1958). Oil on
canvas. 231 x 200.7 cm. (91 x 79
in.). 1973.135. Gift, Lawrence Rubin.*

*Frank Stella emerged as a member
of the postwar generation of Ameri-
can painters confronted by the
achievement and emotionalism of
the Abstract Expressionists. The
loosely brushed bands of* Red River
Valley *attest to the painterly
methods of these artists (whom
Stella emulated during his painting
classes with Bill Seitz at Princeton)
and suggest a kind of atmospheric
space Stella soon abandoned in
favor of a more emblematic abstrac-
tion. The artist has indicated that*
Red River Valley *and other early
works were documents of "wander-
ings," both literal and figurative.
The systematic serial explorations of
formal issues did not begin until a
few months later, with the radical
"Black Paintings" of 1958–1960.*

as opposed to Germanic conception of the significance of the new architec-
ture."[5] The Germanic conception, wedded to utopian schemes of social reform
—or sometimes dystopian or anarchic ones—was perceived as far removed
from the cooler aesthetic of the French, who had first articulated the goal of
l'art pour l'art. Sachs's pronounced Francophilia and the effects of its formalist
bias are also echoed in Philip Johnson's letter of 1930 to the prominent Dutch
architect J. P. Oud (whom Johnson had commissioned to build a house for his
family), in which he describes the plans for Hitchcock's book on the new
architecture:

[We will be] making propaganda in America for Modern architecture.... We shall
not approach the theme from the historical side but in terms of problems of style.
Naturally the critical analysis will be purely aesthetic, to the great disappointment
of our German 'sachlich' friends, who think of nothing but sociology.[6]

71. KENNETH NOLAND
(b. 1924) American
Hover (1963). Acrylic resin on
canvas. 175.3 x 175.3 cm. (69 x 69
in.). 1964.35. Purchase, Louise E.
Bettens Fund.

Noland uses color in Hover *to play a*
structural role—specifically to defy
gravity and suspend the hovering
central gray and red form. This is
a painting Noland wanted to keep
for himself, but the enthusiasm of
Michael Fried (who was working on
the exhibition "Three American
Painters") induced him to agree to
Harvard's purchase of it. Karma,
one of Noland's later chevron series,
was given in recognition of the exhi-
bition the next year. As Fried noted,
the uninflected surfaces of these
color-field works recall the critic
Félix Fénéon's comments regarding
the post-Impressionist painters in
France: "There is no place for bra-
vura—let the hand be numb, but let
the eye be agile, perspicacious,
cunning."

Formalism had attained a position of prominence in the teaching of the fine arts faculty as well. Ironically, its strength in the department came primarily from the Germanic tradition of Kant, Hegel, and Heinrich Wölfflin. Jakob Rosenberg, a former student of Wölfflin in Munich, taught the department's graduate introduction to art history methodology for twenty years, stressing the value of Wölfflin's focus on formal elements. Max Loehr, who joined the department in 1960 as Abby Aldrich Rockefeller Professor of Oriental Art, was also a Wölfflin disciple and applied formalist principles to the study of Chinese ritual bronzes with spectacular results. Perhaps the most eloquent advocate of this method was Sydney J. Freedberg, a Harvard graduate and professor specializing in sixteenth-century Italian painting (now serving as senior curator at the National Gallery of Art). While he placed close study of objects before the analysis of text—an approach well within the traditions of connoisseurship—Freedberg advocated a species of formalism that would have been repellent to the likes of Forbes and Sachs. In his classic essay on the Italian Mannerist painters, Freedberg assigns less importance to the analysis of iconographic systems in which form derives from content and makes

72. KENNETH NOLAND
Karma *(1964). Acrylic resin on
canvas. 259.1 x 365.8 cm. (102 x 144
in.). 1965.22. Gift, Kenneth Noland.*

content explicit, and suggests instead that content can be wholly separate from form:

Whether he quotes literally, or derives only generally, [the Mannerist painter] looks at his source as in the main something to be regarded for its forms; he sees the content of the original as some separable, or at least diminishable factor. He performs upon the vocabulary of his model an operation that results in a kind of petrifaction, and he may then use the cold, pure substance of the vacated form as an element to build with into any context.[7]

The "cold, pure substance" of vacated form, in Freedberg's analysis, is separable from content, inspirational or otherwise, and it is here that Freedberg differed radically from Forbes and Sachs, who placed emotion at the very center of the pictorial experience. The impact of this kind of formal analysis on the graduate students participating in the museum's exhibitions and acquisitions was profound.

In 1939, while still a graduate student at the Fogg, Freedberg helped mount an exhibition for Boston's Institute of Modern Art (as it was then called) titled "The Sources of Modern Painting." Juxtaposing the works of Bronzino and

*In 1967 Stella began a series of
paintings with shapes based on the
protractor and with titles taken
from the names of ancient and Is-
lamic circular cities in Asia Minor.
In a carefully articulated program,
Stella outlined a group of thirty-one
formats, each of which was given
three different surface treatments:
"interlaces" (I), "rainbows" (II), and
"fans" (III). The curves and complex
color schemes of these "Protractors"
were new, as were the gargantuan
scale and the sixteen-inch width of
the bands on some of the pictures.*

*The artist did maintain some tech-
niques from his earlier "Irregular
Polygons," creating the same sense of
spatial ambiguity with flat color.
But in the Protractors, he used more
translucent and subtly ranged
colors. In works like Hiraqla II,
Stella also used unprimed canvas,
assuring a slight bleeding of bound-
aries to continue the "breathing
line" effect of the earlier works.*

Degas, Chardin and Manet, Poussin and Cézanne, the exhibition demon-
strated the continuity of tradition while emphasizing the formal innovations of
the modern painters. Poussin is "a prelude... to the formal experiments of
Cézanne," and in the modern painter we see a "new formalizing tendency."
Moreover, this formalizing tendency takes "a further step toward abstraction"
in the work of Braque and Picasso: "Braque retains an indication of three-di-
mensional mass... whereas Picasso's *Eggs* are reduced to flat shapes in a
decorative pattern."[8]

The sources of tradition and innovation in American modern art were also
seen as coming from Paris, rather than from the more explicitly politicized
centers of northern and eastern European art, a view that was further codified
in the late sixties by a group of brilliant graduate students, among them

74. FRANK STELLA
Bechhofen II *(1972). Oil, cardboard, and fabric on masonite. 251.5 x 269.2 cm. (99 x 106 in.). 1974.1. Gift, Lawrence Rubin.*

Concurrently with the last of the "Protractor" paintings, Stella made forty new sketches in the fall of 1970. The artist executed three versions of each sketch in the series: paint and collage elements on canvas (I), paint and collage elements on wood (II), and paint and collage elements on tilted planes of "TriWall" cardboard (III). By 1974, he had completed one hundred thirty paintings, naming them after wooden synagogues destroyed in Poland during the 1930s and 1940s. The second version of each work in the series (for example, Bechhofen II) begins to read as low relief, because of the thickening of the collage. Suggesting references to perishable form and "the obliteration of an entire culture," the "Polish Village" works also explored Stella's "sense of romance and strength in those structures [the synagogues]."

Michael Fried, Rosalind Krauss, Charles Millard, and Kenworth Moffett. The most cogent statement of "the Fogg school" position can be found in Michael Fried's seminal 1965 exhibition and publication *Three American Painters,* to which John Coolidge has already referred. Reviewing the evolution of modern painting and its roots in France, Fried quotes the critic Clement Greenberg and others to establish the continuity of American art with its European heritage:

this essay attempts an exposition of what, to my mind, are some of the most important characteristics of the new art. At the same time it tries to show why formal criticism . . . is better able to throw light upon the new art than any other approach. To do this, the development over the past hundred years of what Greenberg calls "modernist" painting must be considered, because the work of [American painters since the War] . . . represents, in an important sense, the extension in this country of

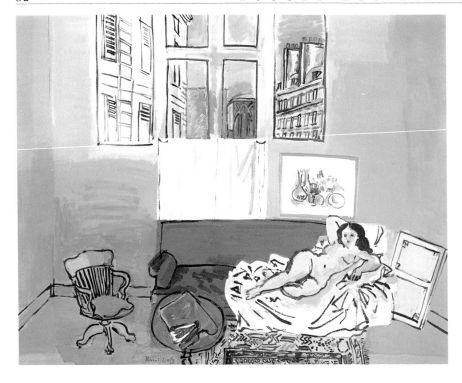

75. RAOUL DUFY
(1877–1953) French
The Artist's Studio, *1928. Oil on canvas. 79.4 x 100 cm. (31¼ x 39⅜ in.). 1954.92. Gift, Mr. and Mrs. Joseph Pulitzer, Jr.*

The Artist's Studio *is one of a series of nudes Dufy painted from 1928 to 1930 in his Paris studio in the Impasse de Guelma. The artist had the walls of this studio painted blue to provide a background that would enhance the purity of the painted lines of his portraits. The solid, saturated background and the open window looking out onto the "real" world relate to such Matisse paintings as* The Red Studio *of 1911 (The Museum of Modern Art, New York). Dufy greatly admired Matisse's work, and, after seeing the latter's* Luxe, Calme et Volupté *(private collection, Paris) in 1905, declared, "At the sight of this picture, I understood the new raison d'être of painting."*

76. GEORGES ROUAULT
(1871–1958) French
Autumn, *1938. Oil on paper. 67.3 x 100 cm. (26½ x 39¾ in.). 1967.71. Gift, Mr. and Mrs. Joseph Pulitzer, Jr.*

Georges Rouault, who studied with Gustave Moreau and is often identified with Matisse and the Fauves, developed his own expressive style, revealing his religious messages through strongly designed, richly colored portraits and landscapes. The sanguine radiance of Autumn *surrounds the traveling figures, who seem to pursue a solemn—perhaps a biblical—quest. The nonspecific figures and abstracted forms of the looming landscape give the picture an iconic, universal quality of melancholy intensity.*

77. PABLO PICASSO
(1881–1973) Spanish
Plaster Head and Bowl of Fruit,
*1933. Oil on canvas. 73.2 x 92 cm.
(28⅞ x 36¼ in.). 1966.138. Gift, Mr.
and Mrs. Joseph Pulitzer, Jr.*

The cool tones and spare composition of this mid-career Picasso evoke the gravity and serenity of the "classical" figures he painted in the 1920s, at the same time that they foreshadow the increasing influence of Surrealism on his work in the late 1930s. The subject is a witty conundrum. On the left, an artwork stands on a pedestal, one of a series of increasingly abstract portraits Picasso made of his beloved Marie-Thérèse Walter, the young schoolgirl he had met on the steps of the Galeries Lafayette in Paris six years before. This "unrealistic" sculpture is contrasted with a "real" bowl of fruit on the right; and herein lies the conundrum. The bowl of fruit, although it exists in the real world of the painting's depicted space, has been rendered by the artist in schematic abstraction. Gone are the modeling shadows, the clear siting on a stable base; instead, we are presented with a free and lyrical interpretation, whose linear exuberance presents a spiritual counterpoint to the depicted sculpture's erotic physicality. Plaster Head and Bowl of Fruit *is thus a joyous celebration of the artist's power and skill as well as a metaphor for art itself. The artist has presented the abstract sculpture "realistically," the real bowl of fruit "abstractly," and in so doing has made us aware of the inherently abstract nature of all art, which can only represent, rather than become, the world itself.*

78. PABLO PICASSO
(1881–1973) Spanish
Woman in Blue, *1949. Oil on*
canvas. 99.7 x 80.6 cm. (39¼ x 31¾
in.). 1959.151. Gift, Mr. and Mrs.
Joseph Pulitzer, Jr.

During World War II, Picasso lived
relatively isolated in France, his only
companion the beautiful, if trou-
bled, Dora Maar. She was Picasso's
subject for a series of portraits, simi-
lar in style and format to this paint-
ing. But by 1949 his primary subject
was Françoise Gilot, who was proba-
bly the sitter for Woman in Blue.
Picasso's use of the frontal eye and
double profile in these portraits con-
veys the sense of anxiety he felt dur-
ing and after the war. One eye in
darkness, one in light, the woman
seems split between two worlds,
fixed to her throne in the shallow
space of a room, like a helpless Cas-
sandra, watching the future become
present. The rich, bright colors and
bold outlining give the portrait the
intensity of light found in stained
glass—perhaps a window onto the
silent temple of the soul.

a kind of painting that began in France with the work of Edouard Manet. . . . Roughly speaking, the history of painting from Manet through Synthetic Cubism and Matisse may be characterized in terms of the gradual withdrawal of painting from the task of representing reality—or of reality from the power of painting to represent it—in favor of an increasing preoccupation with problems intrinsic to painting itself.[9]

Chief among these problems for the new painters, in Fried's mind, was painting's relationship to its support. Frank Stella, in particular, was heralded for "deriving or deducing pictorial structure from the literal character of the picture-support," thereby resolving Cubism's problem with the edge of the canvas by generating the structure or composition of a painting "*from* the framing-edge *in toward* the center."[10] The triumph of American painting,

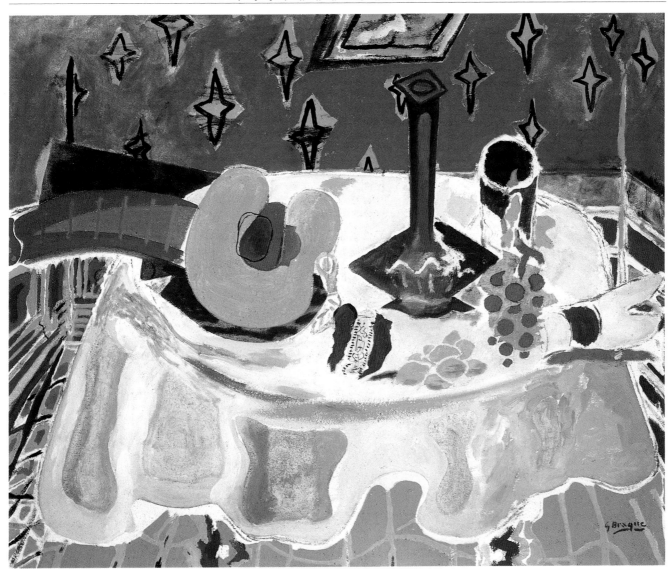

79. GEORGES BRAQUE
(1882–1963) French
Mandolin *(1939–40). Oil on canvas.*
88.9 x 106.7 cm. (35 x 42 in.).
1960.246. Gift, Mr. and Mrs. Joseph
Pulitzer, Jr.

Usually identified as Picasso's
partner in the invention and prac-
tice of analytic Cubism, Braque
moved in his later years toward a
more lyrical form of expression rem-
iniscent of Matisse. Mandolin *is an*
example of the artist's later attention
to color and to the specific formal
identities of individual objects.
These elements, as well as Braque's
interest in pattern—exemplified
here in the strong designs of the
wallpaper and floor—are also natu-
ral developments from the formal
concerns he addressed in his earlier
Cubist works. The Gustav Zumsteg
Collection in Zürich owns Still Life
with Banjo, *another, very similar,*
version of this painting.

80. PAUL CÉZANNE
(1839–1906) French
Portrait of Jules Peyron *(1885–86).*
Oil on canvas. 46.4 x 38.1 cm. (18¼
x 15 in.). 1961.144. Gift, Mr. and
Mrs. Joseph Pulitzer, Jr.

In 1885 and 1886 Cézanne lived in
Gardanne, a town in southern
France not far from his home in Aix.
While in Gardanne, he met Jules
Peyron, a municipal fiscal agent
who witnessed the artist's marriage
to Hortense Fiquet in 1886. In this
mid-career painting of his friend,
Cézanne used thin layers of paint,
reminiscent of his watercolors and in
contrast to the thicker surfaces typi-
cal of his works in oil.

which was fostered initially by the favorable postwar political climate, was celebrated at Harvard for its formal advance beyond Cubism, and only those paintings that were perceived as furthering this advance could be endorsed as worthy of acquisition.

Although alternative modes of art history were practiced at Harvard in the postwar years, the art museums and the fine arts department became known as strongholds of formalism, and the students and staff as the legatees of Berensonian connoisseurship. This formalist connoisseurship informed the exhibitions and publications produced at the Fogg (or by its students else-where) and played a significant role in the acceptance of a certain kind of abstract painting into the Fogg collections: painting that could be justified in terms of a progressive formal or intellectual program, as well as a moral purpose.

81. JUAN GRIS
(1887–1927) Spanish
Violin and Glass, *1915. Oil on*
canvas. 91.4 x 60 cm. (36 x 23½ in.).
1963.117. Gift, Mr. and Mrs. Joseph
Pulitzer, Jr.

In 1911 the Spanish-born painter
Juan Gris embraced the Cubism that
his colleagues Braque and Picasso
had begun to formulate in 1908.
Polished patterns and harmoniously
undulating surfaces set Gris's work
apart from that of the two inventors
of Cubism. Moreover, Gris persisted
in the use of color when his col-
leagues had limited their palettes
exclusively to grays and tans. Violin
and Glass is a superb example of
Gris's powers of abstraction, al-
though the forms of the instrument
and sheet music are still far more
recognizable than the splintered
images found in the earlier analytic
Cubist works of Picasso and Braque.
Gris's interest in the grain and tex-
ture of different materials is appar-
ent in the almost palpable surfaces of
the wood, glass, paper, and string in
Violin and Glass.

82. BEN NICHOLSON
(1894–1982) British
November 1961 E. *Oil on masonite.*
90 x 53.4 cm. (35 x 21 in.).
1972.330. Gift, Margery and Harry
Kahn.

John Coolidge has already described how Fried and others helped inspire his own interest in contemporary art. Fried's work on Morris Louis for a 1967 exhibition[11] prompted Coolidge to purchase (with the help of Lois Orswell) Louis's *Blue Veil* (Fig. 68). This was the first Louis painting to enter a museum collection, and his widow gave *Four-Three-Eight (Orange Column)* in recognition of the Fogg's early commitment (Fig. 69). Even before Fried's landmark exhibition on Noland, Olitski, and Stella, the Fogg purchased Noland's *Hover* (Fig. 71) only months after it was painted; the artist himself gave *Karma* soon thereafter (Fig. 72).

Perhaps even more significant for the future shape of the collection was the "master list" Coolidge compiled of modern artists whose works should be sought for acquisition, the first such systematic effort in the museum's history. Prepared with the help of graduate student Charles W. Millard, then Coolidge's assistant (and now chief curator at the Hirshhorn Museum), this list and the responses it prompted reveal the direction that the collection was to take. It is undated but seems to have been prompted by an early memorandum from another graduate student, Charles Chetham (now director of the Smith College Museum), who pointed out that the collections lacked even a single strong painting from the period between 1907 and 1914, "probably the most significant span in the 20th century." Titled "Our Ideal Collection of 20th century Classics," the list ranges from Picasso (Afro-Iberian, both analytical and synthetic Cubist, collage, "classic 30s," and sculpture, as well as work from more recent periods), to Braque (Fauve, analytical and synthetic Cubist, recent), to Miró, Matisse (Fauve, figure pieces, 1920s, cutouts), Mondrian, Vlaminck or Derain, Brancusi, Calder, early Giacometti, and Pevsner. That Coolidge welcomed and incorporated students' suggestions is attested by a pithy memo from Rosalind Krauss (now professor at Hunter College, City University of New York) on an early draft:

I . . . feel that there is a lamentable absence of either surrealist or dada works but I assume, since it is so noticeable it must be intentional. Personally I would like to see a top quality Orphist work—either Delaunay or [crossed out; appears to be Picabia] in this list, especially if a cipher like Metzinger can figure as a "classic." I feel that Pollock should definitely be on the list; one would be looking for a 1947–50 painting.[12]

Coolidge incorporated the Delaunay and Pollock in the list, and added a

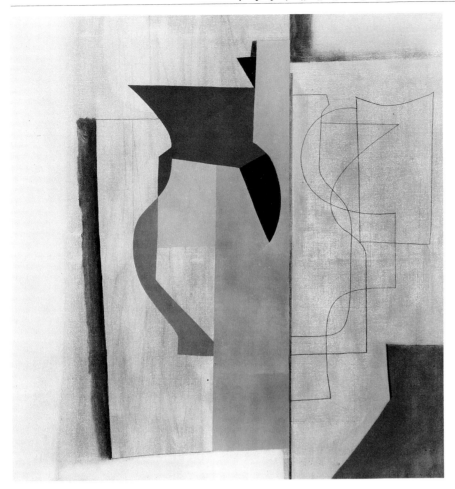

83. BEN NICHOLSON

Dust Blue *(1953). Oil on canvas.*
90.2 x 90.2 cm. (35½ x 35½ in.).
1971.101. Gift, Mr. and Mrs. Joseph
Pulitzer, Jr.

The elegant, attenuated, linear Cubism of Ben Nicholson is well characterized by these two works. Their spare color and delicate tonal harmonies, so pleasing today, belie Nicholson's radical status as a young English artist in the 1920s. The son of two painters and husband to another, Nicholson saw his first Cubist Picasso in 1921. Its colors seemed more real to him than many of "the actual events in one's life," and he went on to produce some of the earliest pure abstractions in England. He has continued to create gently geometric, Arp-like abstract reliefs simultaneously with the undulating vase and jug forms that appear in the Fogg's two paintings.

"documentary" dada piece, Duchamp's *Boîte en Valise* (also known as *The Green Box*). Of the twenty-odd categories listed, the museum was successful in acquiring examples of almost half. With the gifts of Joseph Pulitzer and others, in addition to Coolidge's decisive purchases, the museum acquired a major Pollock, *No. 2, 1950* (Frontispiece), Brancusi's *Caryatid II* (Fig. 49), Picasso's *Plaster Head and Bowl of Fruit* (Fig. 77) and *Woman in Blue* (Fig. 78), a small Derain, a second Metzinger, a Braque *papier collé* and late canvas, *Mandolin* (Fig. 79), and a number of important works on paper. Additionally, there were later Cézannes, among them *Portrait of Jules Peyron* (Fig. 80), an early Gris still life, *Violin and Glass* (Fig. 81), and two mid-career Légers, *Composition* (Fig. 60) and *Les Plongeurs* (*The Divers*) (Fig. 56). As Coolidge has noted, there were also many cooperative purchases with the Busch-Reisinger, which made the collections even more comprehensive.

But although Coolidge incorporated Krauss's suggestions for a broader representation of dada and the Orphist artists in the "ideal list," they were not

84. SALVADOR DALI
(b. 1904) Spanish
Composition—Figures of Drawers,
*1937. Pen and brush with black and
gray ink on white paper. 54.5 x 75.8
cm. (21½ x 29¼ in.). 1957.227. Gift,
Dr. and Mrs. Allan Roos.*

*The inventive mind of the Spanish
Surrealist is well represented by this
superlative drawing, the only Dali
work—and perhaps the finest exam-
ple of Surrealism—in the collection.
Ecstasies both culinary and sexual
commingle with demonic intensity.
Beans, forks, sausages, and chops fly
about the room, and, with grotesque
abandon, women open the drawers
that are part of their anatomy. Dali's
use of a range of traditional tech-
niques heightens the effect of his
draftsmanship, inviting our close
perusal of the nightmare within.*

among the categories actually acquired, and, except for Miró, the Surrealists did not even make it onto the list. Certainly there were first priorities, limited funds, and market considerations, but the gaps that remain in the collection have their own significance as an internal portrait of the operative definition of quality in modern works of art.

The paintings that form the heart of the modern collection exemplify an intellectual or formal program—the first attribute of quality and seriousness in art. Beginning in the Norton era, "merely decorative" art was seen as having no place in the study of art history. Except for the Busch-Reisinger collection, where decorative arts were acquired early and systematically by Charles Kuhn (documenting the great domestic designs of the Bauhaus artists, among others), the decorative arts themselves have never been an important part of the teaching program. Thus a great painter like Matisse, whose lyrical Fauvist landscapes and color-soaked interiors gave the decorative sensibility its finest hour, remains underrepresented in the collection, as do the lesser works of the pattern and decoration painters of the 1970s. To some extent this is simply the serendipity of chance gifts, but it is also because the principal donors are Harvard graduates, whose taste was formed, in part, by the prevailing taste of the university's programs and museums.

Though arguably decorative, the works of the color-field painters endorsed by Michael Fried, Rosalind Krauss, and Kenworth Moffett were seen to

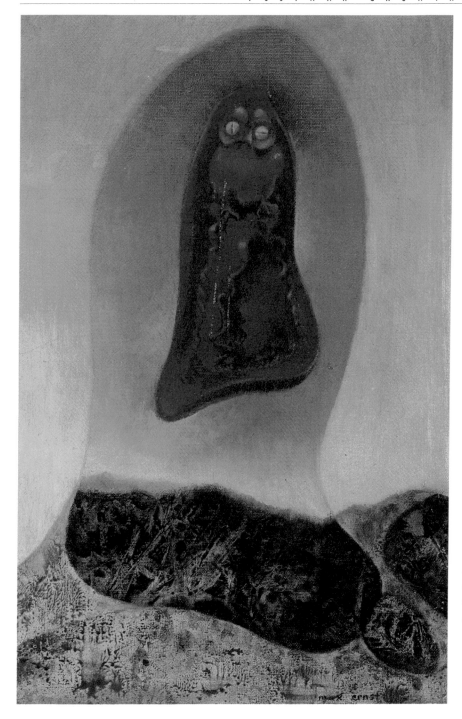

85. MAX ERNST
(1891–1976) German
Untitled *(c. 1933–35). Oil on canvas.*
40.6 x 26 cm. (16 x 10¼ in.).
1979.420. Gift, Sylvia de Cuevas in
honor of Melvin R. Seiden.

As early as 1919, Max Ernst was
making paintings that can only be
called Surrealist, with their depic-
tion of strange apparitions inhabit-
ing a magical world. Although he
stood apart from Surrealist activi-
ties in his unwillingness to partici-
pate in the group's endless personal
and philosophical disputes, his tech-
nical innovations fulfilled their aes-
thetic goals, creating unexpected
juxtapositions through collage and
eerie, unnatural forms through
"frottage" (rubbing, as in the fore-
ground here). In the late 1920s, bird
imagery became increasingly impor-
tant to Ernst, culminating in a
series of paintings in which a trans-
parent egglike form reveals a cluster
of bird personages intertwined to-
gether, as if for shelter or survival.
The Fogg's untitled Ernst is clearly
related to these works. By the 1930s,
the birdman (in the person of Ernst's
creation "Lop-Lop") had become an
autobiographical figure.

participate in a rigorous formal program that was difficult, austere, intellec-
tual, and directly continuous with the great European modernists of the late
nineteenth century. These were serious painters, engaged in a highly moral
endeavor. By this argument, young critics like Fried were returning to the very
attributes of traditional Fogg connoisseurship that Freedberg's ideas had

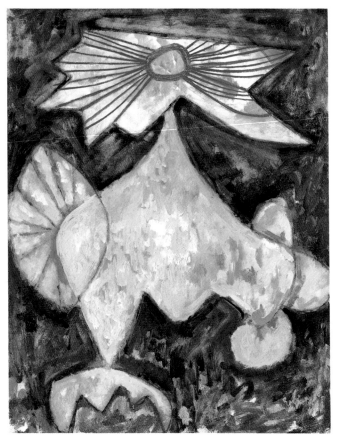

86. WILLIAM BAZIOTES
(1912–1963) American
Bird of Paradise (1947). Oil on
canvas. 95.25 x 74.93 cm. (37½ x
29½ in.). 1949.51. Purchase, Louise
E. Bettens Fund.

Along with Motherwell and other
painters from the New York School,
Baziotes was fascinated by automa-
tism. A leading theme and tech-
nique of the Surrealists, automatism
was intended to communicate sub-
conscious and spiritual elements di-
rectly onto the canvas or paper, the
artist serving merely as a medium
for this transmission. In 1942, after
seeing the Miró and Dali exhibitions
at The Museum of Modern Art in
New York, Baziotes absorbed Miró's
biomorphic imagery and lively
forms. Baziotes translated these in-
fluences into his own language by
consciously manipulating them, un-
like Miró, who expressed his imag-
ery as spontaneous confessions.

87. ARSHILE GORKY
(1904–1948) American
Study for "The Calendars"
(c. 1946). Charcoal and chalk on
paper mounted on board. 83.4 x
102.4 cm. (33 x 40½ in.). 1976.78.
Gift, Lois Orswell.

This heavily worked drawing docu-
ments Gorky's final composition for
an oil painting since destroyed by
fire. Study for "The Calendars"
shows the pioneer Abstract Expres-
sionist's mature style, in which bio-
morphic images float across the
plane of the picture, creating an at-
mospheric world ruled by both heart
and mind. Like the Cubists before
him, Gorky developed an abstract
visual language to represent his
subjects, in this instance the artist
and his family. The details of this
deeply felt domestic scene have been
interpreted to include Gorky (on the
upper right, below one of the wall
calendars, reading a journal), his
wife (holding their baby daughter,
directly in front), and the family dog
(front center). In a tragic denoue-
ment to this private vision of domes-
tic harmony, Gorky committed sui-
cide only two years later after
becoming convinced that his wife
had been unfaithful.

88. ROBERT MOTHERWELL
(b. 1915) American
Elegy, *1948. Paper collage and*
gouache on masonite. 74.9 x 61 cm.
(29½ x 24 in.). 1949.49. Purchase,
Louise E. Bettens Fund.

Motherwell formulated his aesthetic
ideas while studying philosophy at
Harvard, where he focused on the
journals of the French painter
Eugène Delacroix. "Since there was
no place that was teaching painting
as it interested me, philosophy at
Harvard seemed like a good idea,
unpainterly as Cambridge is. Every-
one there has ears, not eyes, or, if
eyes, only good taste." After Harvard,
he discovered the work of the French
Symbolists, and spent his early years

as a painter in New York, learning
from expatriated European Surreal-
ists. Both influences affected his
contribution to the New York School,
as evident in the Fogg's two collages.
In Collage No. 1 *the painted, picto-*
graphic figure evokes the "primiti-
vizing" aspect of the work of Adolph
Gottlieb, while the willed accidents
of the collage elements recall the
ideas of the Surrealists. Elegy *repre-*
sents one of Motherwell's finest col-
lage explorations of a theme that
continues to occupy him after four
decades of sustained production.
Culminating in the massive "Elegies
to the Spanish Republic" of the
1950s, the images are "general met-
aphors of the contrast between life
and death and their interrelation."

89. ROBERT MOTHERWELL
Collage No. 1, *1945. Gouache, wa-*
tercolor, and metallic paint on cut
papers and wood veneer, 54.6 x 36.8
cm. (21½ x 14½ in.). 1949.50. Pur-
chase, Louise E. Bettens Fund.

94

90. **MARK ROTHKO**
(1903–1970) American
The Black and the White *(1956). Oil
on canvas. 238.8 x 136.5 cm. (94 x
53¾ in.). 1981.122. Gift, Ruth and
Frank Stanton.*

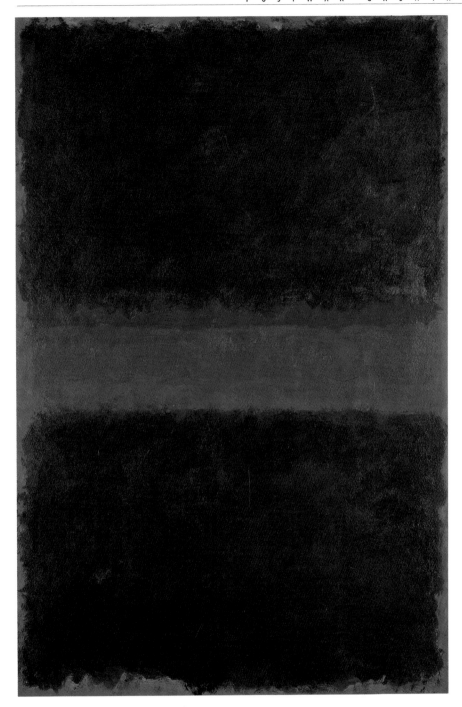

91. MARK ROTHKO
Untitled (Blue-Green) *(1969). Oil on paper on linen. 99.1 x 65.4 cm. (39 x 25¾ in.). 1972.8. Anonymous Gift in memory of Nicholas Gagarin.*

After a sustained period of figurative and Surrealist work, Mark Rothko arrived at a style that was at once lyrical and contemplative. Although grouped with the Abstract Expressionists (and an occasional author of their few manifestos), Rothko stood apart from the heroic gesture, choosing instead to pursue an almost impersonal touch that looked forward to the color-field painters. The Black and the White *helped to affirm Rothko's achievement; it was included in the New York Museum of Modern Art's exhibition "New American Painting," which toured Europe and brought the New York School painters their first international audience.* Untitled (Blue-Green) *is a later work, whose color harmonies and vibrant saturated hues belie the depression to which Rothko was prey during this last year of his life.*

threatened: the investiture of art with a moral purpose and a content that, when properly explicated, could inspire.[13]

As well as participating in a formal program, the works in the collection have a second attribute, which derives from this first perception of content and purpose. Art of the highest quality must have an intellectual program, but before the artwork can be endorsed, its program must be seen as moral or constructive. Thus Surrealism, with its aleatory, misogynistic, eternally fluid

92. HANS HOFMANN
(1880–1966) American
Blue Rhapsody, *1963. Oil on*
canvas. 226 x 188 cm. (89 x 74 in.).
1970.56. Gift, Rosenman, Colin,
Kaye, Petschek, Freund, and Emil.

One of Hofmann's highly abstracted,
sensual late paintings, Blue Rhap-
sody *exemplifies the artist's belief*
that "A work of art is a world in itself
reflecting senses and emotions of the
artist's world." Here the artist es-
chewed brushes and squeezed paint
directly onto the canvas from the
tubes, respecting the canvas edge to
create a spontaneous yet centered
effect. The result is quite different
from the quality of his well-known
"push and pull" paintings, where he
scraped thick layers of paint into
block forms that extend from edge to
edge of the canvas.

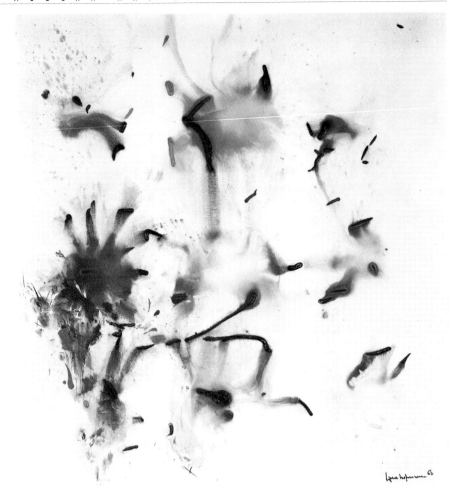

"party line," is represented by a mere handful of works on paper—such as the frightening Dali *Composition* (Fig. 84)—a single canvas by Max Ernst, *Unti-tled* (Fig. 85), and a few surrealistically inflected works, such as William Baziotes's *Bird of Paradise* (Fig. 86) or Arshile Gorky's *Study for "The Calen-dars"* (Fig. 87). Although New York School paintings and works on paper such as the Pollock (Frontispiece), the two Motherwell collages (Figs. 88, 89), and even the Rothkos (Figs. 90, 91) evolve out of Surrealism, appreciation of them was always couched in formal terms. As Coolidge has noted, "none of us was particularly attracted to the Surrealists," and the windfall of the Serts' Miró collection is the exception that proves the rule.

Similarly, the nihilism of dada was perceived as neither constructive nor appealing, and the later, neodada works of such Pop artists as Robert Rauschenberg, Jasper Johns, Claes Oldenburg, Roy Lichtenstein, and others met with the same aloofness.[14] The work of these artists was not acquired until later, and then only as works on paper. The gaps that remain—the need for an early Johns painting or Rauschenberg construction, a Marcel Duchamp or

Man Ray *objet trouvé*, a painting by Roberto Matta or Gorky—have been partially filled by some of the prints, drawings, and photographs that have been subsequently acquired. The museums' intention of maintaining contact with new tendencies in art is centered on the acquisitions in these more intimate media, which have always been a strength of Harvard's fine arts laboratory.

After the departure of Michael Fried and others for jobs outside Harvard, the formalism that had characterized the Coolidge years began to change. This occurred partly as a result of changes in art itself: the conceptual art, performance art, earth art, and body art of the 1970s could not be reconciled with a formalist urge toward flatness or seen as a response to Cubism. Similarly, nontraditional forms of art history were proliferating, with the addition of feminist criticism, deconstruction, and semiotics to the standard approaches of connoisseurship and iconographic analysis. Necessarily, the shifting tides in the outside world affected Harvard and the collections in its art museums. Pluralism was courted openly when the university named Daniel Robbins as the Fogg's director in 1971—but the seeds for change had already been planted by Charles Kuhn at the Busch-Reisinger, by the planners of the Carpenter Center for the Visual Arts, and by a number of influential curators at the Fogg.

93. CORRADO MARCA-RELLI
(b. 1913) American
Composition *(1959). Oil and fabric collage on canvas. 58.4 x 86.4 cm. (23 x 34 in.). 1960.736. Gift, Mr. and Mrs. Joseph H. Hazen.*

Born in Boston of Italian parents, Marca-Relli spent much of his childhood in Europe before moving permanently to New York at the age of thirteen. His earliest paintings reflect a consciousness of modern European painting, particularly the empty courtyards and melancholy cityscapes of Giorgio de Chirico. In the 1930s, he came into contact with a number of New York painters through the Fine Arts Project of the W.P.A. After World War II he helped form the Eighth Street Club, becoming an active member of what would come to be called the "New York School." Although much of his work in the 1950s was loosely figurative in conception, resembling the "classic" phase of early de Kooning, Marca-Relli concurrently pursued such total abstractions as Composition, *always using his signature technique of cut-and-painted canvas collage. A similar work from the same year is the Walker Art Center's* The Joust, *which hints at the theme of combat underlying so much of this artist's work.*

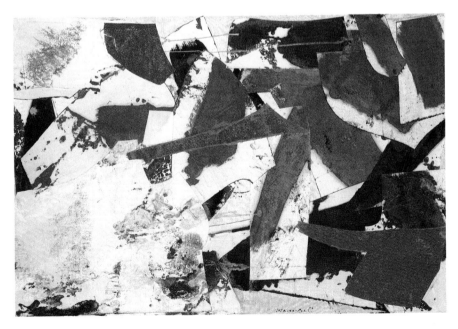

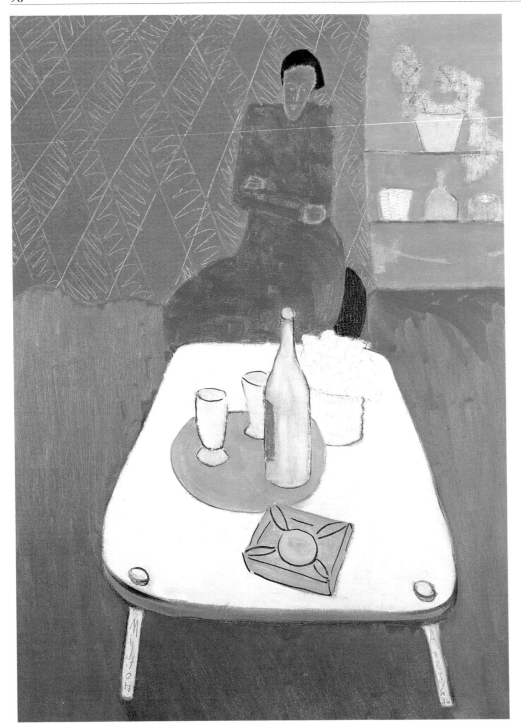

94. MILTON AVERY
(1885–1965) American
Still-Life with Woman, *1946. Oil on*
canvas. 100.33 x 74.93 cm. (39½ x
29½ in.). 1966.85. Gift, Dr. Harold
Gershinowitz.

In his early years, Avery studied at
the Connecticut League of Art Stu-
dents and the School of the Art Soci-
ety of Hartford in Connecticut,
where American Impressionism was
the favored style. It was not until he
moved to New York City in 1925 that
the artist began his experiments in
reducing form to simplified shapes
of flat color that reside deliberately
on the surface of the canvas rather
than creating an illusion of depth or
three dimensionality. By 1944,
Avery's mature style, characterized
by a strong intuitive ability to han-
dle color, had developed. In Still Life
with Woman, *painted during a trip*
to Mexico, Avery produced dense
planes of ruddy, warm colors that
were evidently inspired by the locale.

95. LOUISE NEVELSON
(b. 1900) American
Total Totality II *(1959–68). Painted*
wood. 257.8 x 430.5 x 17.8 cm.
(101½ x 169½ x 7 in.). 1978.531.
Gift, Richard H. Solomon in honor
of Mr. and Mrs. Sidney Solomon.

Born in Russia in the first year of the
new century, Louise Nevelson has
continued for decades to construct
complex, mysterious wall-sized en-
vironments of found wood and
metal scraps. The roots of these
sculptures lie in folk art assemblages
as well as in the more intellectual-
ized aesthetics of dada and Surreal-
ism. Chair legs and backs, lathed
railings, coat racks, and splintered
wood scraps are boxed and stacked,
transformed with black paint into a
unified assemblage that lies some-
where between a complex machine,
a cellular organism, and an altar to
a mysterious private religion.

96. ARMAN
(b. 1928) American
Venu$, 1970. Money in polyester.
Height: 88.9 cm. (35 in.). 1979.432.
Gift, Beldock, Levine, and Hoffman
through the generosity of Elliot L.
Hoffman.

Born in Nice as Armand Fernandez,
Arman began in 1947 to sign his
first name only, a gesture he origi-
nated with fellow artists Yves Klein
and Claude Pascal as the three
hitchhiked through Europe together.
When a printer dropped the final d
in error, Arman adopted the mis-
spelling, which he has used ever
since. During the mid 1950s, an in-
terest in Surrealism led Arman to
participate in a series of what would
later be called "happenings," and he
began to use artifacts from these
projects—crushed violins, smashed
typewriters, broken jars of paint—to
create more permanent art objects by
embedding the refuse in polyester.
These "accumulations" exercised a
special appeal for Arman, who cast
paint tubes, trash, mannequin
hands, and other substances in the
mold of a mannequin's torso (as in
My Love's Color, 1966, Philippe
Durand-Ruel collection, Paris, and
Cold Petting, 1967, Dr. Peter Ludwig
collection, Cologne). The series cul-
minated in Venu$, *the title and*
armless form of which recall that re-
vered icon of traditional art, the
Venus de Milo, *while the accumula-*
tion of cash mocks the art market
with dadaist irony.

5 Toward Pluralism, 1968–1985

THE YEAR 1968 proved to be a watershed in the nation's history and in Harvard's. Hippies, Yippies, Black Panthers, and Weathermen offered a range of protest styles from pacifist to terrorist, but all grew more militant after the violent, nationally televised confrontation with the Chicago city police force during the Democratic National Convention. Student protests against the draft and the American involvement in Vietnam were gathering force internationally and became manifest at Harvard in strikes, sit-ins, and the 1969 takeover of University Hall, the headquarters of administration. The groundswell of activism culminated October 14, 1970, in the bombing of the Semitic Museum, where Henry Kissinger happened to have an office.[1] By the early 1970s, the pervasive sense of rebellion had extended to the sere discipline of art history, and its impact was felt in museums around the country. Picket lines called for the representation of women and Afro-American artists in collections and exhibitions, and artists themselves began to reject even the attenuated form of the "great tradition" represented by "classic" modern art.

Even before this social and aesthetic debate reached Harvard, modest challenges to the dominant view of modern art had arisen from within. While Harvard's fine arts department was achieving a reputation for formalist criticism and the Fogg was building a modern collection focused on the French schools, Charles Kuhn continued to promote northern and central European art at the Busch-Reisinger Museum. John Coolidge became as close and important a colleague as Paul Sachs had been, acquiring objects for the Busch collections and placing Fogg works there on semipermanent loan. Only a few years into his directorship, Coolidge contributed Fogg funds toward the purchase of Lyonel Feininger's *Bird Cloud* (Fig. 51). The great Max Beckmann triptych that Lois Orswell had given—*The Actors* (Fig. 97)—was installed at the Busch, where it could be compared with Kuhn's great purchase of 1941, the Beckmann *Self-Portrait* (Fig. 34); works by Klee, such as *Heisse Jagd (Hot Pursuit)* (Fig. 57), by Klimt, and by others were formally transferred or indefinitely loaned to the Busch. In return, a large portion of the Busch-Reisinger's fine collection of twentieth-century prints were transferred to the Fogg.

97. MAX BECKMANN
(1884–1950) German
The Actors, *1941-42. Oil on canvas.
Center: 199.4 x 150 cm. Sides: 199 x
83.8 cm. (78½ x 59 in., 78½ x 33
in.). 1955.174. Gift, Lois Orswell.*

*Painted in Holland over thirteen
months during Beckmann's exile
from Nazi Germany,* The Actors *is
one of the series of great triptychs
from the artist's later years. Recur-
ring characters such as the bellhop
and the king—the latter a self-
portrait—appear in this and other
triptychs that suggest mysterious
narratives of death and salvation.
After the Nazis invaded Holland,
Beckmann painted secretly in a to-
bacco warehouse. The danger of
painting openly and the utter im-
possibility of selling his work during
these years brought him to the point
of painting on the family's last bed
sheets, a sign of the obsessional need
to create, a need to which* The
Actors *also attests.*

It was Coolidge who initially suggested to Kuhn that he seek the help of
Walter Gropius in securing materials from the Bauhaus for the collections.[2]
Kuhn wrote to the refugees on the list that Gropius had given him and received
an enthusiastic response. Between 1943 and 1947 there had been no acquisi-
tions in what was then called the Germanic Museum, and Kuhn himself had
recommended that it be turned into a Germanic Studies Center. But with the
revitalization of the endowment made possible through gifts from the Busch
family, and the new interest of Coolidge, acquisitions jumped in 1948 to 133,
and to 738 the year after. A large proportion of these acquisitions consisted of
generous gifts from Herbert Bayer, Josef Albers, Walter Gropius, and other
former *Bauhaüslers.* Later, the Alexander and Lydia Dorner gifts would bring
other important paintings such as a rare Kasimir Malevich (Fig. 98) and
important constructivist sculpture such as Naum Gabo's *Construction in Space
with Balance on Two Points* (Fig. 99). A wealth of additional objects and
archival materials from the Dorners, from Lyonel Feininger, and from other
Bauhaus artists gave Harvard the greatest concentration of this quintessen-
tially modern material in America.

Exhibitions at the Busch-Reisinger reflected its renewed sense of purpose.

Retrospectives of Max Beckmann in 1948 and Ernst Ludwig Kirchner in 1950, surveys of the growing Bauhaus collection, and teaching shows (such as "Impressionism versus Expressionism" in 1954) helped balance the picture of modern art at Harvard. At the same time, they conclusively banished the

98. KASIMIR MALEVICH
(1878–1935) Russian
Suprematist Painting, Rectangle
and Circle *(c. 1915). Oil on canvas.*
43.1 x 30.7 cm. (17 x 12 in.).
BR1957.128. Alexander Dorner
Trust.

During the Russian Revolution, Malevich and other painters sought to achieve total purity in their art by reducing formal elements to the square, the circle, and the rectangle, and by using only white and the primary colors. Malevich's Suprematist Painting *is one of his earliest existing abstractions; later he would move toward even more reduced compositions.*

99. NAUM GABO
(1890–1977) Russian
Construction in Space with Balance
on Two Points *(1925). Black, white,
and transparent plastics. Height:
25.6 cm. (10¹⁄₁₆ in.). BR 1958.46.
Gift, Lydia Dorner in memory of
Dr. Alexander Dorner.*

*Like the Duchamp brothers before
them, Naum and Antoine Pevsner
chose separate names in their early
twenties: Antoine kept the family
name, and Naum took Gabo. Both
artists were pioneers of the Con-
structivist movement, which mani-
fested itself in sculpture by the
dissolution of volume and the inter-
penetration of abstract geometric
forms.* Composition in Space *ad-
mirably demonstrates these trends
in Gabo's art and suggests his inter-
est in physics, engineering, and new
synthetic materials. Gabo was liv-
ing and working in Berlin when*
Composition *was made. He came to
Harvard as a professor at the Grad-
uate School of Design in 1953.*

nationalism of the old Germanic Museum (which had lingered only in the museum's name) and replaced it with an ambitious program aimed at representing all of northern and central Europe.

The fifties witnessed other trends that affected the perception of modern art in Cambridge. James Plaut recalled of this period at the ICA:

Conscious as we were of the fact that The Museum of Modern Art was concerned very heavily with the School of Paris and with abstraction per se, while paying far less attention to the extraordinary innovations of northern European painters, . . . we embarked upon a series of exhibitions after the war in an attempt to bring these giants of the twentieth century art to the attention of the American museum public[3]

This goal affected Harvard during James Plaut and Frederick Deknatel's pioneering exhibition of Edvard Munch, held jointly at the ICA and the Fogg in 1950. And in 1956, the university itself commissioned a report on the visual arts at Harvard, which resulted in the creation in 1963 of the Carpenter Center for Visual Arts, together with an undergraduate major in Visual and Environmental Studies.

The new center and department did much to address student demands for a more creative alternative to the professions. Previously Harvard had relied upon the Department of Fine Arts to provide training in the principles of design. With the retirement of Forbes and the departure of Arthur Pope, this seventy-five year tradition declined, and the commissioned report unani-

mously urged that a studio program be reinstated in a "Design Center" adjacent to the Fogg Museum.[4] The site proved feasible, and funds were generously provided by Alfred St. Vrain Carpenter in honor of his son, a former student at Harvard's Graduate School of Design. The university signaled its intention to chart a fresh and forward-looking course by giving Swiss architect Le Corbusier his first American commission.

100. EL LISSITZKY
(1890–1941) Russian
Proun 12 E *(c. 1920). Oil on canvas. 57.1 x 42.5 cm. (22½ x 16¾ in.). BR 1949.303. Purchase, Museum Association Fund.*

Proun is the Russian acronym for "Project for the Affirmation of a New Art," Lissitsky's series of works in an almost scientific program intended to develop a new visual vocabulary for postrevolutionary Russia. An "interchange station between painting and architecture," the Proun paintings attempted to capture a new space in which even gravity is vanquished. In Proun 12 E, *the stable pyramid of Renaissance composition is inverted, and the abstract forms float in a delicate, weightless balance. The painting's restricted palette and elegant, anonymous touch convey Lissitsky's intention to find a new, impersonal voice that would speak to the people.*

101. ANDY WARHOL
(b. 1930) American
Marilyn Monroe, *1967. Silkscreen*
on cartridge paper. 91.4 x 91.4 cm.
(36 x 36 in.). M20,316. Transfer,
Student Print Rental.

Andy Warhol, himself something of
a pop culture hero, has created an
art based on the mass production of
popular icons. By creating numer-
ous editions of each portrait, Warhol
has further ensured the ubiquity of
such world celebrities as Mao Tse
Tung, Michael Jackson, and Marilyn
Monroe. The artist validates the ar-
tificial, material redundancy of our
society through his own participa-
tion in it; the effect of his art is para-
doxical. By elevating mass-media
images to art, he evokes a mass-
media aesthetic, so that Marilyn
Monroe *reverts to its function as*
media image while asserting its
status as an arbitrary artistic form.

102. ROBERT RAUSCHENBERG
(b. 1925) American
Landmark, *1968. Lithograph.*
108 x 76.5 cm. (42½ x 30⅛ in.).
M19,956. Purchase, Special Pur-
chase Fund.

This lithograph, fourth of seven rare
artist's proofs, was acquired by the
Fogg directly from Rauschenberg's
print atelier, Universal Limited Art
Editions. At first glance, Landmark
seems a random collection of images
distributed across the print as if they
were 1960s souvenirs on a bulletin
board. Thin swatches of peach color-
ation begin to resolve the visual ten-
sion, contributing to the rhyming
dynamic of scenic, animal, human,
and mechanical images, many of
which occur twice. Each evocative
image interacts—both visually and
symbolically—making Landmark
finally an integrated whole.

Other initiatives brought the work of contemporary artists to the university. President Derek Bok created a university-wide Office for the Arts, under the dynamic administration of Myra Mayman. Through the "Learning from Performers" program, dancers, actors, jazz and classical musicians, composers, and visual artists visited the campus, among them the painters Robert Motherwell, Jules Olitski, and Helen Frankenthaler.

The Fogg and Busch-Reisinger were also moving in new directions. After his forty-year association with Harvard, Charles Kuhn retired in 1968, and Coolidge left the directorship of the museums that same year. Agnes Mongan became acting director in 1968 and was named director the following year. Through her friendship with the photographer Ansel Adams and Polaroid inventor Edwin Land, she became the advocate of a new art for the collections—photography.

The museums had mounted several exhibitions of photographs but had rarely emphasized the medium's history as an art form. Davis Pratt, an enterprising member of the staff at the Boston Museum of Science, had earlier offered to study Harvard's untapped photography resources. He was asked to

103. JASPER JOHNS
(b. 1930) American
Coathanger I, *1960. Lithograph.*
91.4 x 67.6 cm. (36 x 26⅝ in.).
M20,193. Acquired through the
Deknatel Purchase Fund.

By 1960 Jasper Johns had already
begun to establish a reputation in
New York as a painter with brilliant
new ideas about the representation
of flat, iconic symbols and the po-
tential of paint to create textures
and patterns of great beauty. At this
time, Johns was given a lithographic
stone by Tatyana Grosman, who had
established Universal Limited Art
Editions (ULAE), the first litho-
graphic atelier dedicated to produc-
ing prints by painters. Coathanger I
was among the first editions Johns
executed at ULAE. In this astonish-
ingly accomplished image, an ordi-
nary clotheshanger is rendered as
an isolated icon against the densely
hatched background; lithography
seems the perfect medium for Johns,
whose fascination with plasticity
and its reduction is readily explored
through the intrinsic flatness of the
lithographic stone.

become curator of photography at the Carpenter Center, and his six years of research in Harvard archives and visual collections unearthed daguerreotypes, landscapes from the studio of Degas, Eadweard Muybridge's locomotion studies, and a set of important U. S. Geological Survey photographs by Timothy O'Sullivan from the Museum of Comparative Zoology. In 1969, Mongan encouraged him to mount an exhibition of photographs by Ben Shahn, which prompted the extraordinary gift of some 4,000 prints, negatives, and archival items from the artist's widow, Bernarda Shahn. The Shahn gifts were the first photographs to enter the museums as art objects, although there were already tens of thousands of documentary art-historical photographs in the museums' visual collections. Ironically, these first photographic artworks had not even been listed as part of Shahn's estate—at the time,

104. ROY LICHTENSTEIN
(b. 1923) American
Brushstroke (1965). Silkscreen.
58.4 x 73.6 cm. (23 x 29 in.).
M19,991. Acquired through the
Deknatel Purchase Fund.

This vivid silkscreened print exemplifies Lichtenstein's preoccupation with the paradox of reproduction. The "benday" dots forming the background of the image mimic the screen dots of the half-tone reproduction process, contrasting with the "real" brushstroke, which uses another graphic convention of high contrast simplification to simulate the texture and liquidity of paint. By making his highly artificial stroke available in a potentially infinite number of identical images, Lichtenstein pokes gentle fun at the Abstract Expressionists, whose every stroke was celebrated as a unique "stroke of genius."

apparently no one thought of them as art. Today, however, many critics find them at least as successful as his paintings, a persuasive claim in light of a work like *Mrs. Mulhall and Child* (Fig. 131).[5]

Despite the absence of a formal photography department, the Fogg's collection of photographs grew. In 1971, Edwin Land's Polaroid Foundation contributed the first of several portfolios of Ansel Adams's work. The mysterious, seemingly anthropomorphic forms in *Pipes and Gauges, West Virginia* (Fig. 132) are unusual for Adams, who is best known for his epic landscapes. As chairman of the Visiting Committee, Alfred Barr had called repeatedly for a good program in the history of photography. When Daniel Robbins came in 1971 from the Museum of Art at the Rhode Island School of Design to be the Fogg's new director, he acted quickly on Barr's advice, appointing Davis Pratt associate curator of the new department. Among other changes he would make in the museums during his three-year directorship, Robbins gave the curators a large measure of autonomy in building and managing their collections. Pratt responded to this freedom and solicited funds from the National Endowment for the Arts and from sympathetic members of the Visiting Committee to build a collection that would teach the history of the medium and indicate its new directions. The disturbing work of Diane Arbus—exemplified by *Identical Twins* (Fig. 133)—was acquired shortly after a 1971 Fogg exhibition of her work. The university feared that her powerful imagery might

105. *Daniel Robbins in the Fogg ambulatory, November 8, 1971.*

106. ALFRED MAURER
(1868–1932) American
Abstract Head *(c. 1930). Watercolor*
and gouache on paper. 52 x 39.7 cm.
(20½ x 15⅝ in.). 1967.19. Gift, Lois
Orswell.

The son of a famous Currier and Ives
artist, Maurer rebelled against his
father artistically, adopting various
modernist approaches that dis-
mayed the more traditional artist.
Maurer's suicide a few weeks after
his father's death suggests that his
conflict was never resolved; many of
his late series of "Heads" paintings,
which portray twinned faces emerg-
ing from a single neck or torso, have
been interpreted in psychoanalytic
terms, suggesting Maurer's own
emotional confrontations. This sin-
gle head shows the intensity with
which the artist, in an idiosyncratic
Cubist style, expressed a sense of
isolation.

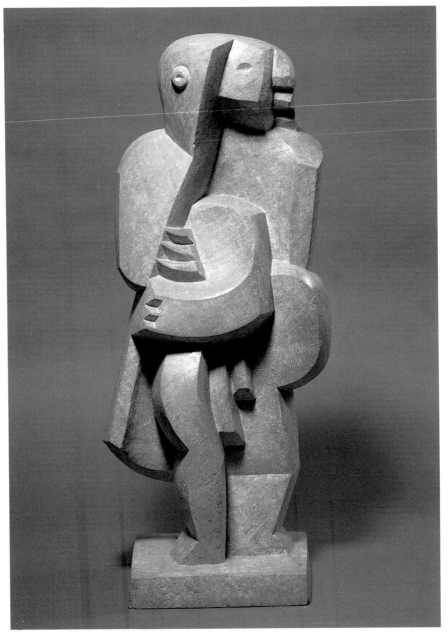

107. JACQUES LIPCHITZ
(1891–1973) French
Bather *(1924). Limestone.*
Height: 68.6 cm. (27 in.). 1960.745.
Gift, Lois Orswell.

Lipchitz arrived in Paris in 1909
from his native Lithuania, and his
naturalistic style evolved rapidly in
response to the Cubists' formal inno-
vations. The Fogg's limestone
Bather *was produced during this*
Cubist phase, just before Lipchitz
began to open his dense geometries
into what he would call "transpar-
encies"—forms with open centers and
revealed structures, reminiscent of
Constructivism, but always within a
representational framework.

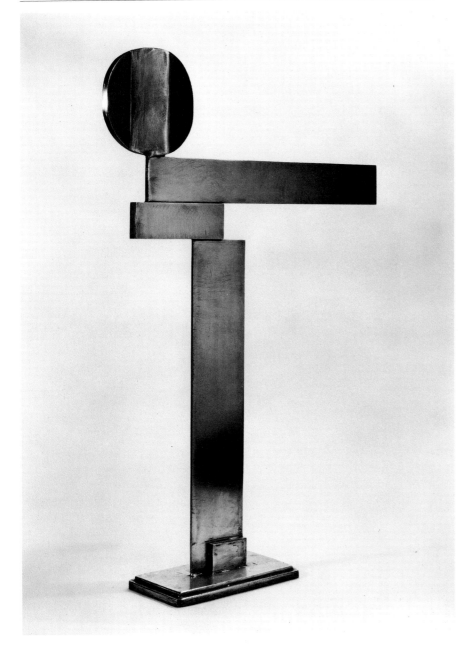

108. DAVID SMITH
(1906–1965) American
Books and Apple, *1957. Silver.*
76.2 x 51.4 cm. (30 x 20¼ in.).
1979.408. Gift, Lois Orswell.

Smith, a robust man who learned to
weld while working in a factory,
constructed this highly streamlined
"still life" just before he began his
monumental stainless-steel "Cubi"
series, pristine geometric shapes
that mark his departure from the
complex intertwining symbolic and
biomorphic forms found in his ear-
lier welded sculptures. The transi-
tional Books and Apple *achieves a*
delicately balanced intimacy un-
usual for Smith. Smith sold the piece
to Lois Orswell, with the under-
standing that it would be given to
the Fogg.

incite vandalism or worse and took out an additional $300,000 in liability
insurance for the exhibition's duration. Classic works by Minor White, the last
of Alfred Stieglitz's disciples, were also acquired—such as *Ritual Branch*,
(Fig. 134)—together with abstract images by Aaron Siskind, including *New
York 7* (Fig. 135). Responding to the excitement generated by the new curator-
ial department, the family and friends of the late Robert Sedgwick provided
funds to purchase Man Ray's classic experiment in solarization, *Femme* (Fig.
136).

Despite his brief tenure, Robbins had a dramatic impact as director of the

109. FRANZ KLINE
(1910–1962) American
Composition *(1952). Oil on canvas.*
137.2 x 85.7 cm. (54 x 33¾ in.).
1959.17. Gift, G. David Thompson.

Kline was born in Wilkes-Barre,
Pennsylvania, where his step-father
worked for the railroad, and it has
been suggested that the bold, black,
industrial shapes that populate his
abstract paintings of the 1950s have
their source in the coal chutes and
roundhouses of his youth. He cer-
tainly painted such scenes in the
1940s, before turning to abstraction.
His conversion to abstraction came
suddenly and irrevocably when he
used a projector to enlarge some of
his small sketches and saw the
beauty of their lines emerge as their
capacity to represent disappeared.
High Street (fig. 5) is one of Kline's
early abstract works, painted with
house painter's brushes and cheap
enamel on poorly stretched canvas.
The cowboy swagger of High Street
becomes more classically contained
and controlled in Composition, *in*
which Kline composes as much with
white as with black.

museums, particularly in the field of modern and contemporary art. In
addition to photography, he gave new impetus to the print department through
his resurrection of the student print rental program. Intended initially to
provide students with reproductions of original artworks, the program was
infused with new fine-art prints, purchased inexpensively from young artists,

110. JOSEPH BEUYS
(b. 1921) German
*Felt Suit (1970). Felt and thread. 170
x 100 cm. (67 x 39⅜ in.). BR1978.4.
Purchase, Eda K. Loeb Fund.*

*Beuys, a political and philosophical
man, approaches his art with the
"desire to evolutionally change an
inhuman reality." From his earlier
multimedia "Fluxus" performance
works to his multiples (of which* Felt
Suit *is an example), Beuys's concern
with survival, the broadening of ex-
perience, and the equivalence of ex-
perience with art has been movingly
and often disturbingly expressed.
According to Beuys, the* Felt Suit *edi-
tions have many meanings. As pro-
tection from the cold, felt signifies
survival and (spiritual) warmth; a
low cost, common material, it im-
plies universality; but, ultimately,
felt is not a durable material, and
thus the suit could never serve as a
real, practical garment. Beuys works
in editions of multiples because he
feels it is crucial to reach as many
people as possible with his ideas.*

which could be rented for the school term. The rental fees were then used for
further acquisitions, and as certain prints increased in value they were
transferred into the permanent collection. Given impetus by Mrs. Frederick
Hilles, a collector and patron of contemporary art, the program enjoyed a
twofold success: the students were given the opportunity to live with original

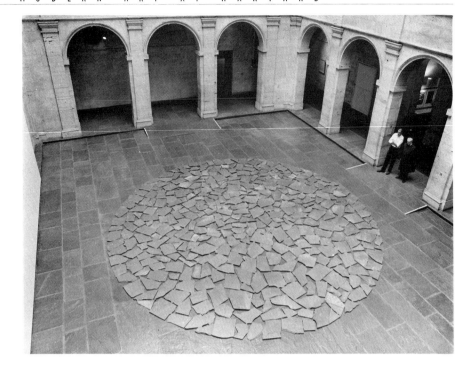

111. *Richard Long's* Red Slate Circle *(April 1980) in the courtyard of the Fogg Art Museum. Richard Long (left) is seen with John Coolidge.*

112. *Mary Miss's* Mirror Way *(Fall 1980) in the courtyard of the Fogg Art Museum. Mary Miss is seen at right.*

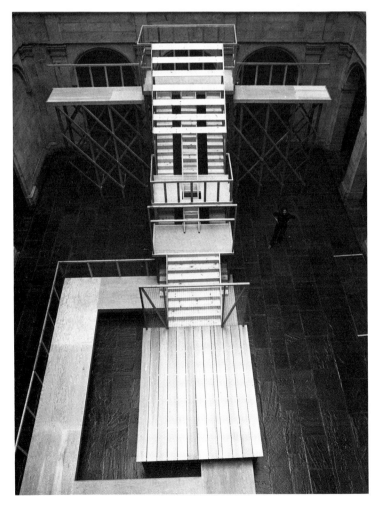

works of art, and the museums could later add once "risky" purchases to the collection. Andy Warhol's *Marilyn Monroe* (Fig. 101), originally purchased in 1977, was transferred to the print collection as recently as 1984. Print curator Henri Zerner, appointed by Robbins after Jakob Rosenberg's retirement, has continued to fill important gaps in the collection with such acquisitions as Jasper Johns's *Coathanger I* (Fig. 103), Robert Rauschenberg's *Landmark* (Fig. 102), Roy Lichtenstein's witty *Brushstroke* (Fig. 104), and a number of early Matisses, exemplified here by the *Seated Nude* of 1906 (Fig. 26).

Robbins felt strongly that undergraduates should be exposed to the very newest contemporary art, art as contemporary as possible with their own generation. Each fall, a small exhibition or installation would be mounted for the incoming freshmen, such as that in 1971 of work by Dan Christensen, Larry Poons, Larry Bell, Robert Irwin, and others. Irwin himself came to the Carpenter Center as a visiting artist under Fogg sponsorship, and he created

113. MARY MISS
(b. 1944) American
Drawing for "Mirror Way," 1980.
Black ink and graphite on vellum tracing paper with acetate overlays. 82.6 x 97.4 cm. (32½ x 38½ in.). 1982.76. Purchase, William M. Prichard Memorial Fund.

With the accuracy of a blueprint, Drawing for "Mirror Way" records the artist's plans for her construction in the Fogg courtyard. Intentionally ephemeral, Mirror Way was dismantled after its display, and thus the drawing is the sole record from the artist's hand of her vision of the piece. Daughter of a military officer and sister of an archaeologist, Miss reflects in her work an interest in forts, earth fortifications, and ancient ruins. However, Mirror Way is a highly cerebral investigation of these interests. Entrances barred, platforms cut off, the stairs and ladders lead only to perilous scaffolding. Like an M. C. Escher labyrinth that cannot be entered, the drawing and structure invite purely visual gymnastics.

114. RICHARD SERRA
(b. 1939) American
Study for "One Plate" *(1972).*
Lithographic crayon on paper.
88.9 x 233.7 cm. (35 x 92 in.).
1977.174. Purchase, with funds from
the National Endowment for the
Arts and from Mr. and Mrs. Joseph
Pulitzer, Jr.

The direct lines of this drawing re-
late to the concreteness of Serra's
monumental sculptures, which, in
their deceptively simple forms, belie
the artist's complex intentions. His
physically stationary but psycholog-
ically dynamic works grow from a
concept of sculpture as experience.
Serra considers the creative process
itself—the unfinished idea, still in
flux, as in this study—to be of pri-
mary importance.

115. SOL LEWITT
(b. 1928) American
Untitled, *1965. Black felt-tip pen on*
paper, 6 panels. Each panel:
21 x 20.6 cm. (8¼ x 8⅛ in.).
1977.49. 1-6. Purchase, with funds
from the National Endowment for
the Arts and from Mr. and Mrs. Jo-
seph Pulitzer, Jr.

This group of six drawings docu-
ments some early installations and

displays many of the characteristics
of LeWitt's later work. Notational
and conceptual art, serial imagery,
primary structures, and the Mini-
malists' reduction of means all recur
in LeWitt's thinking. Unlike his later
wall pieces or layered line drawings,
however, this untitled group shows
LeWitt at a very sculptural moment,
engaged in a series of explorations
of the upright form and its possible
systems of support.

one of his site-specific environments at the museum. At the same time, more permanent works were solicited for the collection. A contact from Robbins's years teaching at Brown, Knoedler Gallery director Lawrence Rubin, gave two major Frank Stella paintings: an early transitional work, *Red River Valley* (Fig. 70) and the Polish Village series construction, *Bechhofen II* (Fig. 74).

Lois Orswell, who had earlier contributed such significant modern paintings as the Beckmann triptych (Fig. 97) and early abstractions by Alfred Maurer and Jacques Lipchitz (Figs. 106, 107), continued her support during the Robbins years and became an extraordinarily important resource through her early friendship with David Smith and her support of other New York School artists. In addition to the major works she has placed on loan from time to time, she enriched the collection immeasurably by such gifts as Smith's

116. CHRISTOPHER WILMARTH
(b. 1943) American
Grey-Blue for Hank Williams No. 2, *1973. Glass, steel, and steel wire. 43.2 x 43.2 cm. (17 x 17 in.). 1973.104. Purchase, Anonymous Purchase Fund.*

Although Wilmarth has stated that "I do not wish to have my art explored in material terms. The materials I use are a vehicle for poetic metaphor, the medium is light, the subject is experience," his materials, glass and steel, enable him to convey his dual interests in light and structure. While it is rigorously nonobjective, his work implies a human presence through its small scale and intimate surfaces. In Grey-Blue, the glass is etched and sandblasted, leading him to categorize this piece as a drawing, despite its three-dimensionality. The artist's emphasis on the touch of his materials, his concern that his art should evoke poetry, and his overt homage to an American country-western hero make Grey-Blue for Hank Williams *a surprisingly warm and appealing work.*

117. JOHN WALKER
(b. 1939) British
Study XI, *1978. Acrylic and char-
coal on paper. 117 x 97.5 cm.
(46¼ x 38⅜ in.). 1979.345. Ac-
quired through the Deknatel Pur-
chase Fund.*

*In 1977 the British painter John
Walker departed from his previously
abstract work to explore space in
which representational elements ap-
pear together with abstract forms.
Beginning with* Numinous I
*(1977–78; now in The Museum of
Modern Art, New York), Walker pre-
sented balcony windows, complete
with shutters on either side, that
draw on such strong historical prec-
edents as Manet's* Balcony *(1868–
69; Jeu de Paume, Paris) as well as
Matisse's treatment of the same sub-
ject in, for example,* Open Window,
Collioure *(1914, private collection,
France). In* Study XI, *Walker further
exploits the juxtaposition of a fairly
realistic rendering of the wrought-
iron balcony and shutters with the
explosion of nonrepresentational el-
ements within. In subsequent work,
the dense, unnameable forms within
the shuttered room take center stage,
no longer coexisting with represen-
tation but creating their own space
and their own world.*

Books and Apple (Fig. 108), Franz Kline's *High Street* (Fig. 5), and, more
recently, the first work by Arshile Gorky to enter the collection, *Study for "The
Calendars"* (Fig. 87).

 After Robbins left in 1974, the museums continued to pursue a broad
pluralism in their representation of modern art, appropriately reflecting the
contemporary art world as a whole. Under Seymour Slive's directorship,
Gabriella Jeppson came from the ICA to serve briefly as acting curator of the
Busch-Reisinger Museum, where she acquired one of Joseph Beuys's most
important and accessible sculptures, the limited edition *Felt Suit* (Fig. 110). In
1980, after becoming assistant director for curatorial affairs and programs,
she mounted a controversial program of installations in the Fogg courtyard,
dedicated to John Coolidge upon his retirement as Boardman Professor of
Fine Arts. The series featured Richard Long, Mary Miss, Patrick Ireland, and
Maria Nordman, each of whom created an intentionally ephemeral artwork in

118. **KARL HORST HÖDICKE**
(b. 1938) German
Schweisser (The Welder) *(1978).*
Synthetic polymer on canvas. 155 x
190 cm. (61 x 74¾ in.). 1984.859.
Gift, Friends of the Nationalgalerie,
Berlin and German Friends of the
Busch-Reisinger.

A member of the new generation of
painters who came of age during
Germany's postwar "economic mira-
cle," Hödicke lives and works in

Berlin, where he has painted scenes
of urban life since the mid 1970s.
Schweisser, or The Welder, *is a par-*
ticularly strong example of this
work, showing Hödicke's increas-
ingly radical simplification of color
and form. The rapidly painted
welder, straddling his T-beam as he
shears off an unwanted length,
stands in for the artist. His flame is
a burst of paint, which seems to illu-
minate the entire sulfurous sky with
an orange light.

119. GERHARD RICHTER
*(b. 1932) German
Saïd (1983). Acrylic on canvas.
260 x 200 cm. (102⅜ x 78¾ in.).
BR1984. 194. Gift, Lufthansa
German Airlines.*

*Richter confounds the cherished
art-historical notion of stylistic evo-
lution by pursuing radically differ-
ent styles simultaneously. Part of the
first generation of postwar German
artists, whose work has been pre-
sented in America only recently,
Richter broke away from the social
realism he had been taught at the
Dresden Academy and staged a
demonstration for "capitalist real-
ism" in 1963. Successive and simul-
taneous styles included a blurred-
focus realism reminiscent of
photographs—"I wanted to do
paintings which had nothing to do
with art"—romantic landscapes and
cloud paintings, and bravura Ex-
pressionist paintings such as Saïd.
Richter's search for a complete neu-
trality of style is pursued through
this bewildering multiplicity, which
reveals Saïd as a gentle mockery of
the Abstract Expressionists' preten-
tions to high seriousness. In this it is
related to the more obvious irony of
Lichtenstein's* Brushstroke *(fig. 104).*

the most public space of the museum. Although most of the works were dismantled and dispersed after their brief stay, Richard Long's *Red Slate Circle* entered the collection of the Guggenheim Museum, and Mary Miss's *Mirror Way* is documented by the drawing that was later acquired for the Fogg (Figs. 111–13).

Throughout the eighties, the museums have remained responsive to the eclectic pluralism of current art. In the collection, as in the art world itself, abstraction has been joined by figuration, formalism by Neo-Expressionism, and conceptualism by narration. The museums hope to be able to document the salient aspects of this current activity. The movement to represent contemporary European art was spearheaded by Charles Haxthausen during his

120. ANSELM KIEFER
(b. 1945) German
Für Chlebnikow: Kleine Panzer-
faust Deutschland, *1980. Gouache
on photograph. 81 x 58 cm. (32 x 23
in.). 1982.48. Acquired through the
Deknatel Purchase Fund.*

*Kiefer joined such contemporary
artists as Baselitz and Hödicke in a
revival of expressionistic figuration
and Germanic themes. One of the
more controversial of the "neo-
Expressionists," Kiefer often refers in
his work to Richard Wagner and
other celebrants of German nation-
alism. He uses strange mixed media
combinations such as straw and tar,
or paint on photographs, as in* Für
Chlebnikow: Kleine Panzerfaust
Deutschland. *The cryptic title seems
to suggest that Germany itself is a
"little antitank device"—a last-ditch,
hand-held weapon for defending the
land. Potentially also a force for rev-
olution, the image is offered in
homage to the revolutionary poet
Chlebnikow, who died in marginal
obscurity after the Russian revolu-
tion. Standing in a hospital gown on
a tree stump under the night sky, the
vulnerable figure (a self-portrait)
offers a revolutionary poetry to the
modern world.*

121. GEORG BASELITZ
(b. 1938) German
Untitled, *1981. Watercolor and chalk
pastel on paper. 60.5 x 42.6 cm.
(23¾ x 16¾ in.). 1982.2. Acquired
through the Deknatel Purchase
Fund.*

*Georg Baselitz is the elder states-
man of a group of young "neo-
Expressionist" painters from Ger-
many, whose work has recently come
to the attention of the American
public. Famous for his series of "up-
side-down" paintings of trees and
animals, as well as portraits of his
friends and family, Baselitz uses*
*this quirky compositional device to
neutralize subject matter in his
work. He nonetheless preserves rep-
resentation at the same time, thereby
questioning both the abstract and
realist traditions of art: a kind of
subversion through inversion. The
blue and orange areas read as ab-
stract forms—until we experience
the blue as the portrait of a man
with a querulous, wide-eyed expres-
sion. Abstract and representational
readings alternate in Baselitz's
work, each equally valid for a post-
war painter who sees representation
as an option rather than a
requirement.*

122. **MIMMO PALADINO**
(b. 1948) Italian
Untitled *(1982). Crayon and*
gouache on paper with wood chips.
59.6 x 77.1 cm. (23½ x 30⅜ in.).
1982.77. Acquired through the
Deknatel Purchase Fund.

Masks, elongated forms, crouching
fetal figures, and death's heads
populate the work of Domenico
"Mimmo" Paladino, who was born
on Paul Klee's birthday in 1948.
Some of the young Italian's early wa-
tercolors evoke Klee's work with their
delicate, abstract, hieroglyphic
quality, but by 1980 Paladino's style
had become much more aggressive.
Reflecting the new narrative im-
pulse in the work of such colleagues

as Sandro Chia, Enzo Cucchi, and
Francesco Clemente, Paladino's
work is inflected by his own prima-
tive vernacular. Deep within a vortex
of gold-painted lines and "force
fields," the striated, skull-like face
of the male figure is counterposed
here with the blue face of the
woman, like yin and yang. Narra-
tive associations abound, from pri-
mal cosmogonies to interpersonal
dialectics, but the world of Klee has
clearly been replaced by a faster,
more perilous universe.

years at the Busch-Reisinger (1975 to 1983) and has taken a new direction under assistant curator Peter Nisbet. Examples of this recent activity include the 1984 gift from the Friends of the Nationalgalerie in Berlin and the German Friends of the Busch-Reisinger Museum, Karl Horst Hödicke's Neo-Expressionist painting *Schweisser (The Welder)*, and one of three recent gifts from Lufthansa German Airlines, *Saïd*, by Gerhard Richter, the complex stylist of the generation that preceded Hödicke's (Figs. 118, 119). In drawings, curator Konrad Oberhuber has continued to collect significant work by both European and American contemporary artists, from Georg Baselitz and Mimmo Paladino (Figs. 121, 122) to Anselm Kiefer and Enzo Cucchi (Figs. 120, 123), to the Americans Katherine Porter, Bill Jensen, and Julian Schnabel (Figs. 124, 125, 127).

Along with the new artistic approaches evident in the growing contemporary collections, new directions have emerged within the Department of Fine Arts itself during the past decade. The department has made increasing use of semiotics, structuralism, material culture, social analysis, and other approaches to the study of art and art activity, with inevitable consequences for the study of modern art. During a period when all curators and historians of contemporary art are attempting to determine whether "modern art" has given way to art of a "postmodern" period—as theorists of literature and architecture have already claimed—these new methods, which help determine what has been excluded as well as included by the mythology of the avant-garde, have become crucial tools in understanding how modernism defines itself.

But while new approaches have evolved from a variety of recent theories and analytical techniques unavailable to prior curators and seemingly discon-

123. ENZO CUCCHI
(b. 1950) Italian
Untitled, *1978. Charcoal, crayon, and graphite on paper. 23.7 x 69.5 cm. (9⅜ x 27½ in.). 1985.1. Acquired through the Deknatel Purchase Fund.*

Cucchi is one of the youngest of the "Italian bad boys" (also known as the "Three C's"—for Cucchi, Francesco Clemente, and Sandro Chia), whose mixture of scatological, sexual, and mythological themes mocks the conventional canons of good taste in art. In their return to representation and narrative, the young Italian painters have also liberated themselves from the tenets of abstraction, long an inviolate requirement of modern painting. In this untitled work on paper, Cucchi depicts a world of dream and myth in which tethered and untethered beings float in dark orbs and open spaces. The teeming figures and sequential narratives, rendered in a range of media from glossy crayon to colored pens, evoke the tradition of illuminated manuscripts with their rich, often demonic detail.

124. KATHERINE PORTER
(b. 1941) American
Untitled *(1981). Charcoal, gouache,
and crayon on paper. 66.4 x 101.4
cm. (26¼ x 40¼ in.). 1981.84. Ac-
quired through the Deknatel Pur-
chase Fund.*

*Porter studied briefly at Boston
University in 1962 and has since
found much support among Boston's
galleries and collectors. Working in
a densely painted minimalism of
grids and zig-zags during the
1970s, she has opened her recent
work to an imagery of targets, rays,*
*vortexes, and other dynamic signs.
She has long been concerned with
politics in her work, which, she
claims, is about "History, natural
things, short wars.... What you see
is what you come up against in the
world." The political content of her
1981 untitled work is unclear, but its
forms evoke the aural abstractions
of early American modernists like
Charles Demuth and Arthur Dove,
or Marsden Hartley in his German
period. Blasts of trumpets, sirens,
and cannons are echoed in the cir-
cular forms, as an explosive energy
is released.*

125. BILL JENSEN
(b. 1945) American
Drawing for Redon *(1976–77).*
Charcoal and graphite on vellum
tracing paper. 57 x 45.4 cm. (22⅜ x
18 in.). 1982.1. Acquired through the
Deknatel Purchase Fund.

The intimate scale and poetry of
Jensen's small abstractions recall the
work of such early American mod-
ernists as Arthur Dove, as well as the
French Symbolist to whom Jensen
openly dedicates the Fogg's drawing.
Where the early American modern-
ists created abstractions of natural
forms or sensory experiences, Jensen
links himself to the Symbolists and
Surrealists, for whom the height-
ened perception of the inner eye re-
veals unconscious truths and em-
powers the creation of a wholly
separate reality. The dreamlike vor-
tex in Drawing for Redon *pulls us*
into this reality with hypnotic force.

tinuous with previous methods, there is a striking continuity of approach within the history of Harvard's art museums. It has been shown that Norton's concern for moral purpose, seriousness, and inspirational content in art became the core of Sachs's and Forbes's connoisseurship, in turn incorporated as the focus of the formalism that governed the Coolidge years. The current interest in the larger context of art and in the social and moral attitudes that inform this context is thus a natural outgrowth of this underlying continuity and, in a sense, brings the department full circle to an expanded and reinvigorated version of Norton's art history. As before, the museums are a laboratory, a means of investigating the connections among artworks and the broader culture that sustains them. The assessment of recent art, bewildering in its stylistic proliferation and its ambivalent relation to the notion of an avant-garde, is no less important than the reassessment of earlier painting. Just as Edward Forbes struggled to convey to undergraduates the importance of the Italian primitives, "who had no knowledge of anatomy, of perspective, of

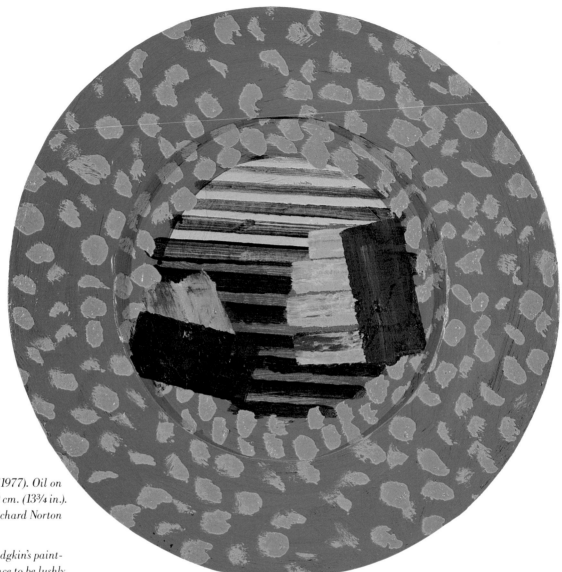

126. HOWARD HODGKIN
(b. 1932) British
Small Simon Digby *(1977). Oil on wood. Diameter: 34.9 cm. (13¾ in.). 1978.71. Purchase, Richard Norton Fund.*

Although Howard Hodgkin's paintings seem at first glance to be lushly and exclusively decorative, his choice of titles—usually a specific reference to place and subject—lend metaphorical significance to his repertoire of painterly strokes and colors. By framing his images in literal, painted frames or in strips of paint that suggest them, the artist often makes the viewer read his paintings as dramatic "scenes" enacted through evocative clues. Small Simon Digby *is unusual in its circular shape, whose border, rather than filling the conventional frame's role of a window opening onto a scene, serves as a porthole through which suggestive, boldly painted bars and lush bands of color are seen.*

foreshortening, or of many of the painter's problems,"[6] the museums will continue to present and explicate the work of our own time, using the theories and methods that seem most effective. Forbes himself had sensed this need as early as 1911, writing of the pioneering Degas show which his colleagues had mounted:

Art is not dead. It is not a memory of the past, nor a butterfly preserved in a glass bottle. It is among us, and is part of our life. We should be alive to the tendencies of our day.[7]

127. JULIAN SCHNABEL
(b. 1951) American
Untitled, 1981. Oil on paper. 96 x
120.7 cm. (38 x 47½ in.). 1982.74.
Acquired through the Deknatel
Purchase Fund.

The youngest artist represented in
this book and exhibition, Julian
Schnabel remains one of the most
controversial. Celebrated for his
"transcendent antifetishism" and
condemned as a product of gallery
marketing, Schnabel emerged in his
mid twenties with the force of a fully
mature artist. His canvases, covered
with broken crockery embedded in
viscous paint, could have been ac-
cepted as neodada assemblages,
except for the fact that Schnabel
painted conventional, representa-
tional portraits (derived from ethno-
graphic photographs or representing
historical or religious figures) on top
of the pottery shards. Evoking the
work of folk artists like Simon Rodia
(who built the famous Watts Towers
from pottery shards and concrete),
Schnabel also courts kitsch associa-
tions in his series of homages to
Oskar Kokoschka painted on black
velvet. By contrast, the work on
paper, as seen here, seems restrained
and serves primarily as a place to
experiment with ideas. A deliberate
return to pure painting, the untitled
1981 piece represents a valid contin-
uation of the impulse of such earlier
artists as Robert Motherwell
(figs. 88, 89).

128. JANE O'NEAL
(b. 1946) American
Untitled (Orange, California), 1977.
Cibachrome print. 34.5 x 50.5 cm.
(13⅝ x 19⅞ in.). P1982.137.
Purchase.

One of a series of photographs
O'Neal took of swimming pool scenes
at night, this image vividly and
symbolically captures an aspect of
contemporary American life.

Through her bold and extravagant
lighting the photographer represents
the barbeque as a divine symbol;
bathed in golden light, its form re-
sembles a cross. Mobile homes hover
behind the fence, and the purifying
waters of the pool stretch behind the
deified oven. O'Neal's photograph
suggests that, perhaps, the barbeque
is the fulfillment of the American
dream.

129. PAUL DIAMOND
(b. 1942) American
Life in San Francisco *(1977). Photograph. Entire sheet: 41 x 51 cm. (16⅛ x 20 in.). P1982.178. Purchase.*

This complex, multilayered composition is atypical of Paul Diamond's oeuvre, which consists primarily of single figures captured in psychologically and emotionally charged moments. Life in San Francisco *is a visual game toying with three layers of reality: first, the woman hovering playfully (or menacingly?) in the top of the frame, a huge, groundless, distorted torso; second, a moving man, his limbs tracing his motion through space; third, a body resting at the base of the background buildings. In this single riotous image, Diamond expresses the chaotic, atomistic quality of urban life.*

130. JOYCE NEIMANAS
(b. 1944) American
Untitled *(1982). Polaroid photograph collage. 81.3 x 101.6 cm. (32 x 40 in.). P1983.4. Purchase, National Endowment for the Arts Grant.*

Born and trained in Chicago, Joyce Neimanas now lives on the West Coast. She continues to create the kind of Cubist photo collages represented by this untitled work, but now modulates their dissonance by coloring the framing edges of the individual photographs. This particular work, photographed by Neimanas and assembled in collaboration with the model, reads like a dream image incompletely remembered. All of the elements of the scene, represented in close-up Polaroid shots, are assembled slightly off-center, while some images are repeated several times. The result is the suggestion of a shattered reality composed of dozens of incomplete pieces of the whole.

131. BEN SHAHN

(1898–1969) American
Mrs. Mulhall and Child, Ozark
Family, *Arkansas, 1935. Photo-*
graph. 19.7 x 24.4 cm. (7³/₄ x 9⁵/₈
in.). P1970.2812. Gift, Bernarda
Shahn.

Ben Shahn considered himself a
painter, and used photographs pri-
marily as sources for paintings.
Hired by the Depression-era W.P.A.,
Shahn was lured from the painting
section to the photography section by
project director Roy Stryker. Mrs.
Mulhall *was taken at this time, and*
was originally titled by the govern-
ment, "Destitute Sharecroppers in
Arkansas," in an effort to dramatize
the plight of America's agricultural
workers. Shahn's photographs were
not considered part of his artistic es-
tate; as a consequence, in 1969 his
widow Bernarda was able to give the
Fogg 3,000 of Shahn's prints, mak-
ing this collection of Shahn photo-
graphs the largest in the United
States.

132. ANSEL ADAMS

(1902–1984) American
Pipes and Gauges, *West Virginia,*
Portfolio V (1939). Photograph. 49.8
x 39.3 cm. (19⁵/₈ x 15¹/₂ in.).
P1971.10. Gift, Polaroid Foundation,
Inc.

The Harvard Art Museums own
every Ansel Adams portfolio made
after 1927. Adams is best known for
his large, meticulously detailed pho-
tographs of grand nature scenes, but
Pipes and Gauges *shows the same*
concern for technical perfection and
dramatic lighting that character-
izes his famous landscapes of the
American West. Adams's composi-
tional genius is also manifested
here. Despite the industrial subject,
the balance of pipe forms, joints,
gauges, and masses of iron gives the
image a delicate poise.

133. DIANE ARBUS
(1923–1971) American
Identical twins, Cathleen and Colleen, members of a twin club in New Jersey, 1966. *Photograph. Entire sheet: 50.8 x 40.7 cm. (20 x 16 in.). P1972.2. Purchase, National Endowment for the Arts Grant.*

Arbus reveals a fascinating psychological dichotomy between the two girls pictured here: on the left is Cathleen, stern, introverted, and seemingly unforgiving; on the right is Colleen, shyly open and friendly. Identical images in different attitudes, the twins suggest two sides of the same person, confronting us with our own potential for similar conflict. It is believed that this was among the last set of prints Arbus developed before she took her own life in 1971.

134. MINOR WHITE
(1908–1976) American
Ritual Branch (1958). *Photograph. 23.5 x 29 cm. (9¼ x 11⅜ in.). P1972.181. Purchase, National Endowment for the Arts Grant.*

Minor White's photographs, which attempt to eliminate the false pictorialism of some early practitioners in favor of purely photographic form, exemplify the tradition of "straight photography." Influenced by his long association with Alfred Stieglitz, White exploited Stieglitz's theory of "equivalents"—in which a photographic image of nature can stand in for an emotion or deeply held belief. The gnarled form of this surreal branch has been removed from any definable context; it hovers over a glowing crown or halo of ineffable light. The image is timeless and suggests mysterious religious import.

135. AARON SISKIND
(b. 1903) American
New York 7 (1951). Photograph.
49.5 x 39 cm. (19½ x 15⅜ in.).
P1972.216. Purchase, National
Endowment for the Arts Grant.

The Harvard University Art Museums hold one of the world's largest collections of Aaron Siskind's photographs. Siskind, who did not become active in photography until he was in his thirties, began as a social documentary photographer. He is best known now for the abstractions he has been producing since the 1940s. New York 7 exemplifies his masterful ability to express the beauty of surface textures by isolating abstract segments. He has brilliantly captured the sensuous texture of the porous background and the seemingly orchestrated rhythm of the ancient, shredded sign that partially covers it.

136. MAN RAY
(1890–1976) American
Femme, 1930. Solarized photograph. 29.5 x 22 cm. (11⅝ x 8¾ in.).
P1977.20. Purchase, Robert M. Sedgwick II Fund.

The ethereal beauty of this masterpiece by Man Ray, the celebrated Surrealist photographer, was created through "solarization," a darkroom technique in which the photographic print is briefly exposed to light during development, achieving the eerie edge reversal of tonality we see here. The solarization process exemplifies the Surrealists' interest in using chance and accident in their work, for its effects can never be fully predicted or controlled. Man Ray produced many portraits of celebrities; this print, however, is less a portrait of Mary Gill, a Parisian courtesan, than it is an exquisite experiment in the manipulation of photographic form.

Notes

Introduction

1. For a discussion of the roots of modernism, see Henri Zerner and Charles Rosen's *Romanticism and Realism* (New York: Viking, 1984) and Michael Fried's *Absorption and Theatricality: Painting and Beholder in the Age of Diderot* (Berkeley: University of California Press, 1980), among others.

2. This book does not document long-term loans or promised gifts that may be installed as part of the exhibition. The museums will publish a comprehensive catalogue of the Maurice Wertheim Collection later in the inaugural year; therefore, this important group of late nineteenth- and twentieth-century art is not covered here. The arrangement of the exhibition is not determined solely by art-historical period. The Fogg galleries house works that will regularly be on view. In addition to works on paper, the Sackler's special exhibition gallery is installed with paintings too large for the Fogg. A selection of modern German art, long the strength of the Busch–Reisinger, is on view at that museum together with a selection of recent acquisitions of twentieth-century European art.

"The Education and Enlightenment of the People"

1. I am grateful to John Coolidge for sharing with me his research on Richardson. Henry James, *Charles W. Eliot* (Boston and New York: Houghton Mifflin Co., 1930), vol. 1, pp. 36–37. Information on MIT from Committee on the Visual Arts, Massachusetts Institute of Technology, *Art and Architecture at MIT: A Walking Tour of the Campus* (Cambridge: Committee on the Visual Arts, MIT, 1982), pp. 5, 51.

2. See Walter Muir Whitehill, *Museum of Fine Arts, Boston: A Centennial History* (Cambridge: Harvard University Press, 1970), Nathanial Burt, *Palaces for the People: A Social History of the American Art Museum* (Boston: Little, Brown & Co., 1977), Calvin Tompkins, *Merchants and Masterpieces* (New York: Dutton, 1970), and others.

3. Letter from Charles W. Eliot to Arthur T. Lyman, Rome, April 18, 1865, quoted in James, *op. cit.*, p. 147. Eliot on teaching quoted on pp. 161–163.

4. That Norton was named literary executor of Ruskin's estate attests to the strength of their friendship.

5. James Lee Love, *The Lawrence Scientific School in Harvard University, 1847–1906* (Burlington, N.C.: 1944), p. i.

6. Marjorie Cohn will document Gray's important role in American culture in her forthcoming publication *Francis Calley Gray and the Collecting of European Prints in America*, which is being produced to accompany the Harvard University Art Museums' forthcoming exhibition of the Gray collection of engravings. I am indebted to Mrs. Cohn for sharing her research on this period with me.

7. Agassiz first taught at the Lawrence School of Science, although he had left for the Museum of Comparative Zoology by the time of Moore's tenure.

8. George Chase, "The Fine Arts," in Samuel Eliot Morison, *The Development of Harvard University* (Cambridge: Harvard University Press, 1930), pp. 130–31. Norton's interest in the natural sciences, and how this interest affected his art history and archaeological endeavors, is worth further exploration. See his *The Poet Gray as Naturalist, with Selections from His Notes on Systema naturae of Linnaeus and Facsimiles of Some of His Drawings* (Boston: Goodspeed, 1903).

9. Edward Forbes tells an amusing story of the undergraduates' response to such criticisms: when Norton concluded a lecture by proclaiming that only two men were the true standard bearers of Western culture, mutters of "you and who else?" were heard in the exiting crowd. Presumably, one of the men was Ruskin.

10. Last will and testament of Mrs. William Hayes Fogg, Fogg Art Museum Archives; hereinafter, FAM Archives.

11. Edward Forbes, *History of the Fogg Museum of Art*, undated typescript in the FAM Archives, ca. 1947–55, p. 88; hereinafter, *History*.

12. See Norton's article "The Department of Fine Arts and the Fogg Bequest," *Harvard Graduates Magazine* 1, no. 1 (October 1892): 118–19. Norton also objected vehemently to the plans for the building in a letter to one of the committee members: "no design can be satisfactory that does not provide for the prospective housing under one roof of all University collections of objects of art; that does not contemplate large growth; that does not secure ample room for the exhibition of the collections...and that does not admit of such arrangements as shall make its collections permanent means for the cultivation of the eye and judgement of students who have no other means of obtaining this culture" (Norton to Edward W. Hooper, March 3, 1893, Harvard University Archives; quoted in Denys Sutton, "A Gentleman from New England," *Apollo* 107, nos. 195 and 196 [May and June 1978]: 4).

13. Forbes, *History*, FAM Archives; also see Agnes Mongan, *Edward Waldo Forbes, Yankee Visionary* (Cambridge: Fogg Art Museum, 1971), p. vii.

14. Martin Brimmer '49 and Edward Hooper '59, *Harvard Graduate's Magazine* 3, no. 11 (March 1895): 303.

15. Professor H. C. G. von Hagemann, chairman of Harvard's German Department, quoted in "The Dedication of the Germanic Museum of Harvard University," special issue of *German American Annals* (Philadelphia: German American Press [January 1904]), p. 2.

16. Kuno Francke, "Deutsche Kultur in den Vereinigten Staaten und das Germanische Museum der Harvard-Universität," *Deutsche Rundschau* 28, no. 7 (April 1902): 127.

17. Quotation from Brimmer and Hooper, *op. cit.* Also see, for example, Forbes's comments in a 1921 address: "The question arises in the individual mind, 'How may I prepare myself to receive the message of inspiration from the great artists of the world?'... We must try to find the true centre, and like Copernicus bring order out of chaos.... A certain intellectual pleasure can be received from... study of a picture, but far more important is the emotional stimulus that the picture gives" (Forbes, "The Appreciation of Art," address given at Carleton

College and published in part in *Carleton College News Bulletin* [March 1921]; pp. 8–9 of revised version published privately some time after November 13, 1941, FAM Archives).

18. Norton midterm quoted in Forbes, *History*, p. 6. Meyer Schapiro, "The Armory Show" (1952; reprinted in *Modern Art: 19th and 20th Centuries, Selected Papers* [New York: Braziller, 1978]), pp. 160–61.

19. Edward Forbes, "The Relation of the Art Museum to a University," *Proceedings of the American Association of Museums* 5 (1911): 52.

20. Forbes, *History*, p. 164. Apparently, Bettens was annoyed by Forbes's initial resistance, for Forbes goes on to relate that "he attacked me in a letter which he sent to various museums and universities" (*ibid.*).

21. Edward Forbes, "Recent Gifts to the Fogg Art Museum and What They Signify," FAM Archives, unpaginated reprint from *The Harvard Alumni Bulletin* (February 1, 1917).

22. Forbes, *History*, p. 666. Forbes also tells a story of visiting Picasso in 1922. "The master" had mounted an obscure collage in the entranceway, and Forbes remained convinced, thirty years later, that the work was a test of credulity. Those who would express awe or interest, he felt sure, would be taken for fools.

The Fine Arts in a Laboratory

1. Paul J. Sachs, "Tales of an Epoch," unpublished typescript (completed in Cambridge, 1958), p. 28; hereinafter "Tales." On deposit in the Fogg Art Museum Archives; hereinafter, FAM Archives.

2. The Forbeses had lived in the house briefly, but the owners immediately prior to Sachs were Walter and Louise Arensberg. These pioneering collectors of modern dadaist works had moved their household to New York, where they would host for years a convivial salon attended by Duchamp, Man Ray, Katherine Dreier, and others.

3. Author's interview with Agnes Mongan, February 1, 1985.

4. Sachs, "Tales," p. 112.

5. Sachs, "Tales," pp. 70, 112, 164.

6. Quotations, Sachs, "Tales," p. 165. Also see Fogg Art Museum, *The Fine Arts in a Laboratory* (Cambridge: Fogg Art Museum, 1924), p. 4. I believe that this small brochure explaining the goals of the "Division of Fine Arts" was written mainly by Sachs, as large portions of it appear in paraphrase in his memoirs. The frontispiece, which bears a quotation on art from Ralph Waldo Emerson, is probably Forbes's contribution.

7. Sachs, "Tales," pp. 169, 345, 367.

8. Sachs, "Tales," p. 371.

9. Sachs, "Tales," p. 210. Fogg Art Museum, *The Fine Arts in a Laboratory*, p. 4. Berenson to Sachs, quoted in Sachs, "Tales," pp. 368–69.

10. Henri Matisse in *Le Point* (July 1939), as quoted in Fogg Art Museum, *Memorial Exhibition: Works of Art from the Collection of Paul J. Sachs* (Cambridge: Fogg Art Museum, 1965), unpaginated catalogue, entry 73.

11. Sachs, "Tales," p. 293.

12. Author's interview with Agnes Mongan, February 1, 1985.

13. "National service" pledge from Fogg Art Museum, *The Fine Arts in a Laboratory*, p. 13, *passim*. Sachs, "Tales," p. 214.

14. See Fogg Art Museum, *Handbook* (Cambridge: Fogg Art Museum), 1931, 1936, and subsequent editions. Ironically, the tide has now turned, and it is considered retrograde to exhibit tribal objects out of context. In 1927, it was extraordinarily innovative.

15. Harvard Society of Contemporary Art, *First Annual Report*, FAM Archives.

16. Charles Kuhn, conversation with Busch-Reisinger staff members, recorded by Emilie Dana in file memorandum for July 13, 1982, Busch–Reisinger Museum.

17. "Modern Architecture: International Exhibition" (New York: The Museum of Modern Art, 1932). Francis Henry Taylor, "African Baroque in Hartford," *Parnassus* 6 (March 1934): 11; quoted in Eugene R. Gaddis, ed., *Avery Memorial, Wadsworth Atheneum, The First Modern Museum* (Hartford: Wadsworth Atheneum, 1984), p. 19.

18. Author's interview with Agnes Mongan, February 1, 1985.

19. Headline from *The Boston Herald* (October 2, 1941). *Guernica* file, FAM Archives. (There are still rumors that the Fogg had the chance to buy *Guernica* or have it on semipermanent loan. Although a marvelous story, there is no evidence in the file to suggest any truth to it.) Paul Sachs to Alfred Barr, telegram September 24, 1941, FAM Archives.

20. Profiles of Winthrop can be found in two Fogg catalogues: *Grenville L. Winthrop, Retrospective for a Collector*, 1969, and Marjorie Cohn and Susan Siegfried's *Works by J.–A.–D. Ingres in the Collection of the Fogg Art Museum*, 1980. Grenville Winthrop, quoted in Cohn and Siegfried, *ibid.* p. 7. A profile of Wertheim will be published in the forthcoming handbook *The Maurice Wertheim Collection of Late 19th- and Early 20th-Century European Art*, by John O'Brian.

21. Sachs, "Tales," p. 240. Author's interview with Agnes Mongan, February 1, 1985. Cohn and Siegfried, *op. cit.*, p. 7.

22. Wassily Leontief, former director of the Society of Fellows at Harvard, remembers discussing with Wertheim the possibility that the paintings could be installed permanently at the society's proposed dining room in the new Holyoke Center. When the Fogg became the beneficiary, Leontief turned to Mark Rothko and commissioned the suite of Harvard mural paintings now under the museums' care. Because the Wertheim bequest required that the collection be permanently on view as a separate entity, the paintings and sculptures are not covered in this catalogue.

The Acquisitive Years

1. Coolidge file on Modern Art, Fogg Art Museum Archives.

Postwar Growth and New Directions

1. See Serge Guilbaut, *How New York Stole the Idea of Modern Art* (Chicago: University of Chicago Press, 1983) for a detailed account of this development. Although Guilbaut belittles the real achievement of the New York School

painters, he provides a stimulating analysis of the major documents of the period. "Free minds" quotation from Roberts Commission report, cited in Sachs, "Tales of an Epoch," unpublished typescript (completed in Cambridge, 1958), p. 345; hereinafter, "Tales."

2. *Guernica* file, Fogg Art Museum Archives; hereinafter, FAM Archives.

3. Bernard Berenson to Sachs, quoted in "Tales," pp. 368–69.

4. Gilman file on the Harvard Society for Contemporary Art, FAM Archives.

5. Helen Searing, "International Style: The Crimson Connection," *Progressive Architecture* 63, no. 2 (February 1982): 90, 89. Alfred Barr may have been the first source for this use of the term "International Style." Until The Museum of Modern Art exhibition and catalogue (see note 17, "The Fine Arts in a Laboratory"), the term had been reserved for the international manifestation of the late Gothic style.

6. Philip Johnson to J. P. Oud, translated from a published Dutch version and quoted by Searing, "International Style," p. 88.

7. S. J. Freedberg, "Observations on the Painting of the Maniera," *The Art Bulletin* 47, no. 2 (June 1965): 191.

8. Institute of Modern Art, *The Sources of Modern Painting* (Boston: Institute of Modern Art, 1939), pp. 25, 27. The exhibition was held at the Museum of Fine Arts in Boston from March 2 to April 9, 1939.

9. Michael M. Fried, *Three American Painters: Kenneth Noland, Jules Olitski, Frank Stella* (Cambridge: Fogg Art Museum, 1965), pp. 4–5.

10. *Ibid.*, p. 41. Fried's focus on the philosophical or aesthetic implications of an art's technology may have its source in his discussions with Harvard philosopher Stanley Cavell, whose writings on film explore the implications of that medium for aesthetics.

11. Museum of Fine Arts, Boston, "Morris Louis 1912–1962," April 13–May 24, 1967; also presented at the Los Angeles County Museum of Art and the City Art Museum of St. Louis.

12. Coolidge file on Modern Art, FAM Archives.

13. See Michael Fried's argument in *Three American Painters* that "the actual dialectic by which [modernist painting] is made has taken on more and more of the denseness, structure and complexity of moral experience—that is, of life itself, but life lived as few are inclined to live it: in a state of continuous intellectual and moral alertness" (p. 9).

14. In the late seventies, the undergraduate humor magazine *The Harvard Lampoon* wanted to commission a sculpture by Claes Oldenburg for the Harvard campus, in commemoration of its centennial. Although the Fogg, represented by John Rosenfield and Seymour Slive, was very enthusiastic, this time the project was defeated by President Derek Bok, whose knowledge of Yale's experience with Oldenburg's saucy *Lipstick* rendered him extremely cautious.

Toward Pluralism

1. Arthur Beale, director of the museums' Center for Conservation Studies, relates a hair-raising story of an anonymous phone call received the night before the

attack, suggesting that any particularly fragile objects be removed for safekeeping. He drove over with an assistant in his station wagon and removed as much as possible, but there was still considerable damage to the museum's collection.

2. Busch–Reisinger file of Kuhn's conversation with Charles Haxthausen and Emilie Dana, 1982.

3. James Plaut interviewed by Robert Brown, June 29, 1971; quoted in Lasse Antonsen, "An Outline for a Comprehensive History of the ICA," (unpublished typescript, Boston: Institute for Contemporary Art Archives, 1983).

4. Harvard University, *Report of the Committee on the Visual Arts at Harvard* (Cambridge: Harvard University, 1956). The seven-man committee had been appointed by President Pusey in response to the recommendation of the Visiting Committee for the Fogg and the Department of Fine Arts. Members included John Walker, Chief Curator of the National Gallery of Art and former co-organizer with Lincoln Kirstein of the Harvard Society for Contemporary Art, and John Nicholas Brown, one of the Society's former trustees.

5. Another interesting note in the long struggle of photography for status as an art form is the fact that most of Shahn's photographic portraits, made under the auspices of the federal government's Work Projects Administration, were labeled by the Library of Congress as "Arkansas Farmer" or "Subsistence Farmer, Missouri." With the help of Mrs. Shahn, most of the families and individuals in the Harvard collection have now been identified, their names restored, and the dignity of the portrait and the subject reaffirmed.

6. Edward Forbes, "Recent Gifts to the Fogg Art Museum and What They Signify," *The Harvard Alumni Bulletin* (February 1, 1917; unpaginated reprint, Fogg Art Museum Archives).

7. Edward Forbes, "The Relation of the Art Museum to a University," *Proceedings of the American Association of Museums* 5 (1911): 53.

Notes to the Captions

FRONTISPIECE. Quoted in "My Paintings," *Possibilities* 1, no. 1 (Winter 1947–48): 79.

FIGURE 8. Albert André, *Renoir* (Paris: Les Editions Georges Crès et cie, 1923), p. 7.

FIGURE 13. Judith Cladel, *Aristide Maillol—sa Vie—son Oeuvre—ses Idées* (Paris: Editions Bernard Grasset, 1937), pp. 91–92.

FIGURE 15. Bazille to his parents May 16, 1870, quoted in John Rewald, *History of Impressionism*, 4th ed., rev. (New York: The Museum of Modern Art, 1973), p. 242.

FIGURE 18. Letter from John Marin at "291" to Alfred Stieglitz in Europe, 1911, in Herbert Seligmann, ed., *Letters of John Marin* (New York: Privately printed for An American Place, 1931), n. pag.

FIGURE 21. Quoted in *Edward Hopper Retrospective Exhibition* (New York: The Museum of Modern Art, 1933), n. pag.

FIGURE 22. Raymond Escholier, *Matisse from the Life* (London: Faber and Faber, 1960), p. 155.

FIGURE 23. Fogg Archives.

FIGURES 28–31. Hartley to Norma Berger, July 11, 1910, from Hartley papers at the Beineke Rare Book and Manuscript Library, Yale University, New Haven, Connecticut; quoted in Barbara Haskell, *Marsden Hartley* (New York: Whitney Museum of American Art and New York University Press, 1980), p. 21.

FIGURE 37. John Rewald, *Edouard Manet Pastels* (Oxford: Bruno Cassirer, 1947), p. 27.

FIGURE 41. Quoted by Jean Boggs in *Edgar Degas: His Family and Friends in New Orleans* (New Orleans: Isaac Delgado Museum, 1965), p. 89. Degas to Lorentz Frölich, quoted in John Rewald, *The History of Impressionism*, 4th ed., rev. (New York: The Museum of Modern Art, 1973), p. 276.

FIGURE 46. Untitled article from the Fogg Archives, in *The Art News* (February 3, 1910), p. 105.

FIGURE 64. Raymond Escholier, *Matisse, ce Vivant* (Paris: Librarie Arthème Fayard, 1956), pp. 161–62; quoted in Henry Geldzahler, "Two Early Matisse Drawings," *Gazette des Beaux-Arts*, VI périod, tomb LX, cent-quatrième année, 1126 livraison (November 1962): 500.

FIGURES 71, 72. Felix Feneon, *Les Impressionistes en 1886* (undated pamphlet), n. pag.; quoted in John Rewald, *Post Impressionism: From van Gogh to Gauguin*, 3d ed., rev. (New York: The Museum of Modern Art, 1978), p. 89.

FIGURE 74. Frank Stella interviewed by April Bernard and Mimi Thompson, "Stella's Third Dimension," *Vanity Fair* 46, no. 9 (November 1983): 94.

FIGURE 75. Quoted in Jacques Lassaigne, *Dufy* (Geneva: Skira, 1954), p. 22.

FIGURES 82, 83. Quoted in John Russell, *Ben Nicholson* (London: Thames and Hudson, 1969), p. 15.

FIGURES 88, 89. Quoted in "A Conversation with Robert Motherwell," *Harvard Magazine* 78, no. 2 (October 1975): 36. Quoted in *An Exhibition of the Work of Robert Motherwell* (Northhampton, Massachusetts: Smith College Museum of Art, 1963), p. 16.

FIGURE 92. Quoted in *Hans Hofmann: The Small Late Paintings* (New York: André Emmerich Gallery, 1982), n. pag.

FIGURE 100. Seymour Slive and Charles Haxthausen, *The Busch-Reisinger Museum/ Harvard University* (New York: Abbeville Press, 1980), p. 26.

FIGURE 110. Götz Adriani, Winfried Konnertz, and Karin Thomas, *Joseph Beuys: Life and Works* (Woodbury, New York: Barron's, 1979), p. 212.

FIGURE 116. Letter from the artist, May 10, 1981, Fogg Curatorial Files.

FIGURE 119. Gerhard Richter interviewed by Bruce Ferguson and Jeffrey Spaulding in unpaginated brochure (Halifax: Nova Scotia College of Art and Design, 1978).

FIGURE 124. Katherine Porter interviewed by Joan Smith, "Expressionism Today: An Artists' Symposium," *Art in America* 70, no. 11 (December 1982): 73–74.

FIGURE 127. See Ross Bleckner, "Transcendent Anti-Fetishism," *Artforum* 17, no. 7 (March 1979): 50–55.

Index

Figure locations appear in boldface. Page numbers in italics refer to caption discussions.

PHOTOGRAPHY CREDITS
All photographs courtesy of the Harvard University Art Museum's Photo Services Department except for figures 3 and 4, by Rick Stafford.